PRAIS
MINDING

D1626969

"Priscilla Long has read wide and deep in the practice of artists of all stripes, and she has meditated to good purpose on what she's found. She is particularly good on the cross-fertilization of artistic methods, with the result that this book is wise, practical and illuminating, a friendly aid to creation."

—Janet Burroway, author of *Losing Tim, A Story Larger Than My Own, Bridge of Sand, Imaginative Writing,* and *Writing Fiction*

"*Minding the Muse* is an artist's answer to the over-asked questions: 'Do you write with a pen or pencil?' Priscilla Long's new book, rich with real life examples, gives creators in all disciplines concrete ways to shape a personal daily practice that invokes the power of the sleeping muse."

—Barbara Earl Thomas, painter

"On days when the isolation of working in solitude can feel overwhelming, it helps to have the wise and supportive voice of poet, writer, and master teacher Priscilla Long whispering in your ear that making art is a possibility, and that you, like the many artists quoted in this book, have something worthwhilep to say."

—Bruce Black, author of *Writing Yoga*

"Like mushrooms, facts must be gathered; like dough; a draft must rest in order to rise. Drawing on vivid anecdotes from a range of artists, this book makes her case that creativity thrives in the balance between spontaneity and discipline. Long's voice is conversational and witty, seasoned by her experience

as an accomplished poet and essayist. *Minding the Muse* is a gift to anyone ready to take their craft more seriously."

—Sandra Beasley, poet, author of
Don't Kill the Birthday Girl: Tales from an Allergic Life
and *Count the Waves*

"With stunning freshness and clearmindedness, Priscilla Long explores how to live a life in consonance with one's creative goals. She offers inspiring advice from many high-achieving creative individuals. Readers are certain to come away with renewed confidence and many practical maneuvers they can't wait to try. On the balance scales, in terms of usefulness and of being a joy to read, this short book outweighs dozens of others on the topic."

—Susan K. Perry, PhD, author of the bestselling
Writing in Flow, "Creating in Flow" blogger at
PsychologyToday.com, and author of the novel,
Kylie's Heel

"Do you get bogged down in creating the works you imagine? Priscilla Long's handbook pulled me right in, to help me move beyond where I get stuck—making space, dealing with feelings, getting out in the world, and more. This accessible, comprehensive, and, well, creative, book is a gift for anyone who wants a fruitful, creative life."

—Sondra Kornblatt, author of *Restful Insomnia,* and
A Better Brain at Any Age

MINDING THE MUSE

Also by Priscilla Long

Fire and Stone: Where Do We Come From?
What Are We? Where Are We Going?

Crossing Over: Poems

The Writer's Portable Mentor:
A Guide to Art, Craft, and the Writing Life

Where the Sun Never Shines:
A History of America's Bloody Coal Industry

(editor) *The New Left: A Collection of Essays*

MINDING THE MUSE

A HANDBOOK FOR PAINTERS, COMPOSERS, WRITERS, AND OTHER CREATORS

Priscilla Long

cp
coffeetownpress

Seattle, WA

coffeetown**press**

Coffeetown Press
PO Box 70515
Seattle, WA 98127

For more information go to: *www.coffeetownpress.com*
www.priscillalong.com

Cover design by Sabrina Sun
Cover art *The Painter's Hand* by Chuck Smart

Minding the Muse

ISBN: 978-1-60381-363-1 (Trade Paper)
ISBN: 978-1-60381-364-8 (eBook)

Library of Congress Control Number: 2016939844

Printed in the United States of America

To Geri Gale,
Jack Remick,
and Don Harmon.

To M. Anne Sweet.

To Gordon Wood.

Peerless peer artists

This thing for which you have sought so long is not to be acquired or accomplished by force or passion. It is to be won only by patience and humility and by a determined and most perfect love.

—Alchemist Morienus, 1593, quoted by C. G. Jung, *Psychology and Alchemy*

TABLE OF CONTENTS

INTRODUCTION

YOU ARE A PAINTER. Or you are a composer. Or you are a poet or a novelist or an essayist. This little book gathers insights from creators both past and present, as well as from creativity researchers, on the experiences and working methods of poets, painters, and other artists.

The choices and strategies of effective creators—creators able to shape a significant body of work over a lifetime—often differ from those of talented and creative people who end up with a small, scattered, or unremarkable pile of effects. Some of these effects may be excellent, but taken as a whole they fall short of the creative worker's potential.

Over the years I've studied the lives of artists and writers from Picasso to Patti Smith, from Raymond Chandler to the great Russian poet Anna Akhmatova. I've wanted to see what I could learn about how they went about their lives and work. I've used my own discoveries and those of creativity researchers to inform and improve upon my own strategies as a writer and poet. I find that no matter how experienced I get, there's something more to learn. Here you have what I've gleaned so far.

Whether you are an old hand or just starting out, it can be helpful to reflect from time to time upon your own art practice. What has worked well for you? What could you improve? *Minding the Muse* is intended to aid you in this process of reflection. If you find here even one or two ideas to fertilize your working process, its purpose will have been served.

Questions to Contemplate as You Continue Your Practice

 Peruse these chapters in any order that strikes your fancy. I suggest beginning a notebook in which to reflect on your own art practice. On each subject, begin by describing what the reality is right now, since our efforts to move forward must necessarily proceed from a good comprehension of reality. Write for ten minutes on your present situation ("My current situation with regard to — is..."). Do not stop. Do not worry about correctness or eloquence. Then write for five more minutes in response to the question: How can I make my practice in this area more effective by 5 percent?

 First session: Write for ten minutes, looking in on your art practice from the outside. What do you see? In your own terms, what are your most effective habits and strategies? What could use work?

I.

PRODUCTIVITY:
LEARNING TO WORK

I am a work horse. I like to work. I always did
I've never had a day when I didn't want to work
And even if I didn't want to compose ... I painted or
stacked the pieces or something. In my studio I'm as
happy as a cow in her stall.[*]

 —Louise Nevelson, sculptor

LEARNING TO WORK is about learning to sink into the work. Learning to be patient with the work. Learning to work every day, even if only for a short time. Learning to eschew distractions.

 Learning to work is learning to drop conditions under which you "can work" or "will work." Conditions like "When I get more time" or "If this novel 'works' [meaning gets published and makes me rich and famous], then I will write

* Louise Nevelson, *Dawns and Dusks,* taped conversations with Diana Mackown, 1976, in *American Artists on Art from 1940 to 1980* ed. by Ellen H. Johnson (New York: Harper & Row, Publishers, 1982), 42.

another." Or, "I can only work when I can get a block of three or four hours."

Work begets work. When we learn to simply work—without fuss, without undue anxiety, without trepidation concerning whether we will create the masterpiece of our dreams or fail to create this masterpiece—the work begins to carry the worker. It begins to make itself.

For the disciplined creative worker, working is not a decision or a big effort. It's a daily habit, a routine. In her book *The Creative Habit*, dancer and choreographer Twyla Tharp writes, "I come down on the side of hard work."* In 1920 the painter Joan Miró wrote to a friend, "I am working as *much as I can*. People who have managed to do something have followed different paths, *but they have never deviated from hard work*."†

Work can be trouble and no fun and seem to go nowhere. One of the effective strategies of effective creative workers is to keep working anyhow. At the age of thirty-three (in 1935), the great Swiss sculptor Alberto Giacometti decided to begin working from a live model once again. He estimated that this departure from his current practice would take about two weeks. "But," he wrote to a friend, "the more I looked at the model, the more the screen between reality and myself thickened. You begin by seeing the person who is posing, but gradually every possible sculpture interposes itself between the sitter and you. The less clearly you actually see the model,

* Twyla Tharp with Mark Reiter, *The Creative Habit* (New York: Simon & Schuster, 2003), 6, 7.

† Joan Miró to E. C. Ricart, Montroig, August 22, 1920 in *Joan Miró: Selected Writings and Interviews* ed. by Margit Rowell (Boston: G. K. Hall & Co., 1986), 74.

the more unknown the head becomes."* His two-week digression ended up lasting five years.

Another time, at the end of 1941, Giacometti decided to return to Switzerland from his home in Paris to see his mother. He planned a stay of three months. His sculptures, to his distress, had been growing smaller and smaller. Before leaving Paris, he promised his brother Diego that he would return with a sculpture of a "less absurd" size. A larger sculpture.

Three months went by. Giacometti worked for hours and hours every day. This too went on for five years. In 1945 he wrote to his lover, "I started the same thing over and over, never getting it right. My figure ended up so minuscule every time and the work was becoming so imponderable and yet it was nearly what I wanted to achieve and it's only during the last year I've managed it but not to the point I want, the *size*, yes, yet I know that I shan't give up the one I've been working on since September [he's writing in May] and that I shall finish it in spite of everything"

That year, according to his friend and biographer David Sylvester, he returned to Paris on the night train, "bringing with him the residue of three years' work in six matchboxes."†

We could ask here, what was Giacometti's problem? Why not just get the job done? But Giacometti was attempting to actually *see* the figure. He was struggling with perception. The strangely thin and elongated figures he became known for resulted from how he perceived. In an interview he said, "I think we have for so long automatically accepted the received idea of what a sculpted head should look like that we have

* David Sylvester, *Looking at Giacometti* (New York: Henry Hold and Company, 1994), 92.

† Sylvester, *Looking at Giacometti*), 95.

made ourselves completely incapable of seeing a head as we really see it."[*]

It's not about working fast. It's about returning to the work day after day, inquiring of it what it needs and giving it what it asks for. It's a conversation, a dialogue, at times an argument. It's a relationship. As long as we keep steady, keep the faith, keep on returning to the work, the work will keep on giving us back what we need to complete it.

The dancer Twyla Tharp writes of her workout each morning: "My morning ritual is the most basic form of self-reliance; it reminds me that, when all else fails, I can at least depend on myself."[†]

My own intention is to put in four hours of work a day, but my bottom line is to write for a minimum of fifteen minutes every day. On some days I get my four hours. On most days I get at least an hour or two, but there's virtually no day when I do not write at all. I write in a notebook by hand. I connect to the page, I connect to who I am and to what I do and to what I want to do. I connect to the day, to the quality of light, to the state of the leaves or branches at my window, to the sound of traffic or airplanes or to the silence (early on a Sunday morning). I do not put conditions on this first write of the day, but write whatever comes to mind. I let my mind drift.

There's such a thing as making a *decision* to be productive. Being productive as opposed to being saddled with a sporadic work habit gives a lot back to the creator. You can play with different forms, each form informing other forms. In creative nonfiction, for instance, I've found

[*] Sylvester, *Looking at Giacometti*, 125

[†] Tharp, *The Creative Habit*, 14.

it entertaining to go from diptych (two parts that mirror or react to each other) to triptych (three parts, ditto) to abecedarian (the form that goes from A to Z). You get, piece by piece, a lot more experience. You develop more skill to bring to the next piece. Also, each piece is asked to carry less weight in the artist's lifetime body of work, and this in turn affords an easier, more fluid working process.

A key strategy toward sinking into the work you dream of doing is giving up the requirement for a long stretch of hours in order to do anything. Work in short stretches of time. Push out distractions. Try fifteen minutes. Try a half-hour.

Another key strategy is to work on more than one piece at a time. The pieces begin to interact with one another. And, if one story or painting or poem is giving you trouble, you can give it a rest and turn to another. The painter Françoise Gilot—originally better known as Picasso's partner (*Life with Picasso*) than as the significant artist she developed into—writes, "Often in the same day I will work on three or four different paintings. I always have about ten to twelve paintings in the making at any given time When I enter my studio each morning, I find canvases under way as well as blank ones, and if I feel pretty good, or, if after an hour I feel pretty good, I then get a larger canvas and begin something new."[*]

The writer and translator Lydia Davis, whose quintessential creative form is the very short story, said in an interview, "One habit I have that is helpful, I think, is that I will often work on several stories at once, leaving one and going on to the next. Then I will sometimes let some days

[*] Françoise Gilot, *An Artist's Journey* (New York: The Atlantic Monthly Press, 1987), 15, 18.

go by before I look at the stories again. By then they are less familiar to me, so it is easier to see how to work on them."[*]

If you are writing a book, especially a first book, I beg you to work on short pieces at the same time. This gives practice in *finishing* pieces. I've met way too many writers who are dabbling on a first book year after year, bogged down, never finishing. Learning to work is in part learning to finish, and this is easier to learn—*much* easier to learn—on short pieces.

Make goals that are specific and reachable by your own efforts. A goal is a product, such as a painting or a poem. It's not a process. For example, "I will work for three hours tomorrow" is not a goal. It's part of the process for working toward a goal. In his book *Creating*, Robert Fritz lays out how creative goals should be expressed as products to be created.[†] My goal this month is to write four poems on glaciers in the context of global warming. It's a goal, whether or not I attain it, which depends entirely on my own efforts. A goal such as *publish* four glacier poems mostly depends on other people (although I do have to send them out). It might be a fine goal, but it's not a creative goal.

In Fritz's useful protocols, after setting the goal, you break down steps required for reaching the goal. Here's where working for a specified amount of time fits. Work doing what? For my goal of four glacier poems, for example, I will spend time gathering language (Antarctic, glacier snout, calve). I will write for a half hour or more in the writing-practice manner (in which you set a timer and write continuously without stopping, also known as discovery writing) on the subject of

[*] Sarah Winterfield, "An Interview with Lydia Davis," *Five Points* Vol. 15, No. 3 (2013), p. 40.

[†] Robert Fritz, *Creating* (New York: Fawcett Columbine, 1993).

the poem. I will fiddle lines. And so on.

Of course creative products are not predictable; that's the territory we're in. We are not a tire factory. We are not delivering newspapers or flipping hamburgers or calculating interest rates. In his book *Art Heals*, Shaun McNiff, artist and art therapist, writes of the "ancient truth that the journey [of the creative process] will take us to surprising and unexpected places if we submit to it" and that "the most significant discoveries cannot be planned in advance."*

We submit to the process and take pleasure in the journey. The art weaver Joan Potter Loveless described (in *Three Weavers*) how she began one particular tapestry. Her first step was to dye "a batch of oranges, brewing and mixing skeins in several pots, trying to get many steps of orange—rosy ones, bright light ones, rusty ones What I'm really after is colors that I can't easily name—strange colors. It's good when I can't predict just how they'll look when they are together, which direction they'll go in. Then they demand real attention and direct their own handling and create surprises for me, leading me where I had not planned to go. This is what I really like"†

When you have completed a piece, celebrate. Even when you have achieved a step toward completing a piece, celebrate. This is no empty requirement. Reward yourself. Give yourself something spiffy and cool—an afternoon at the museum or zoo, an ice cream, whatever pleases you immensely. For your average workaholic creator—of which I am one—this can be a rather trying step to take. But do try.

* Shaun McNiff, *Art Heals: How Creativity Cures the Soul* (Boston: Shambhala Publications, 2004), 19.

† Joan Potter Loveless, *Three Weavers* (Albuquerque: University of New Mexico Press, 1992), 118.

What I like to do is to spend a few hours at an art museum, by myself, musing and looking. Then I treat myself to lunch at the museum café. Then I go to a coffeehouse and write in my favorite notebook, currently a Leuchtturm1917 "Master Classic" notebook. It has a hard black cover with rounded corners and an elastic fastener. Its 233 large pages, ruled and cream-colored, have a place at top for the date. It has contents pages in the front, a pocket in the back, and a page-marker ribbon. I fill its beautiful pages with whatever strikes my fancy.

Meeting a goal gives you a resting place. We need resting places. If you're working on a big project that's never done, you never rest. You may develop resistance to the whole bloody thing. Making a goal, breaking down the steps required to reach that goal, celebrating when you have achieved a step or two, celebrating the finished work—these strategies give you resting places.

Once we experience the feeling of deep rest after completing a work, it's natural to strive to get there again. And again. This practice has nothing whatever to do with external praise or rewards—exhibits, prizes, publications, sales. It has to do with attitudes and practices that we creators put in place for ourselves. It's private and it's personal. It's our relationship with our own work.

Questions to Contemplate as You Continue Your Practice

What is your work practice? Do you work every day? Do you place various unattainable conditions on when, where, or how you can work, resulting in a sporadic work habit? If so, how might this be improved?

What specific products do you aim to achieve during your next period of work (week, month, year)? What are the steps to achieving them?

Do you work on more than one piece at once? Do you allow the pieces to interact with each other and influence each other?

When you next complete a work, what will you do to reward yourself? Which work will this be?

II.

GATHERING, HOARDING, CONCEPTUALIZING

Each book has a notebook—a kind of first home that scraps of it might be tempted to visit. The notebook must be small enough to fit in my pocket, big enough to accommodate drawings, screams, doubts, plans, journal entries, records of self-loathing, and fragments of whatever story I'm trying to invent. The notebook must be willing to go with me everywhere: to be wet, worn, dirty, and occasionally thrown across the room.[*]

—A. L. Kennedy, writer, performer

ANY PARTICULAR PLANNED WORK benefits from a gathering stage. Objects, lists of words and phrases, photos, pictures and words cut from magazines, maps, fast drawings, discovery-writing sessions, studies of the sort done

[*] Alison Louise Kennedy, "Notebooks Thrown Across Rooms," in *How I Write: The Secret Lives of Authors* ed. by Dan Crowe (New York: Rizzoli International Publications, Inc., 2007), 62. A. L. Kennedy's website may be found at *www.a-l-kennedy.co.uk*.

by visual artists—all are forms of gathering.

Joseph Cornell[*]—the great collagist and assemblage artist, maker of scenes within shoebox-sized boxes that function as windows into his dream-mind or into our movie-star, Barbie-doll culture—gathered and hoarded obsessively. He collected, categorized, and placed in dossiers objects that informed his works or that might become part of a work. He sorted, fiddled with, fingered, re-sorted, purchased, and at least once, purloined these objects. He haunted thrift shops. His detritus filled the house he shared with his mother. He assembled and re-assembled. Out of these gathered and hoarded objects, he created worlds.

What objects? Cornell collected mirrors, maps, dolls and doll parts, sheet music, watch springs, compasses, stamps, shells both natural and plastic, paperweights, clippings, and magazine cut-outs sorted into categories such as "nudes" or "birds" or "Garbo." He collected bottle stoppers, thimbles, toys, plastic spiders, and cut-outs of figures from Old Master painting reproductions. He collected pillboxes and photographs and pencil sharpeners. He collected twigs and grasses. He collected rings, driftwood, ballerina dresses, swatches of blue velvet, newspapers, postcards, old phonograph-record sleeves. He collected coins and brass rods and scraps of paper with things written on them. Beyond collecting objects, he was in a nearly constant state of note-taking.

W. B. Yeats[†] filled notebooks with what he called

[*] Lindsay Blair, *Joseph Cornell's Vision of Spiritual Order* (London: Reaktion Books, 1998).

[†] Curtis B. Bradford, *Yeats at Work* (Carbondale: Southern Illinois University Press, 1965).

"subjects" for poems—prose paragraphs with a concept and often an image or two. Although he wrote many more subjects than he wrote poems, almost all of his poems began with a subject. Often the poem ended up far from its subject, but the subject was the motor that got it going. Yeats's subjects were to his poems what Cornell's amassed detritus was to his boxes.

The choreographer Twyla Tharp starts each new composition with a box. "I write the project name on the box, and as the piece progresses I fill it up with every item that went into the making of the dance. This means notebooks, news clippings, CDs, videotapes of me working alone in my studio, videos of the dancers rehearsing, books and photographs and pieces of art that may have inspired me."[*]

Raymond Chandler began writing crime stories in his forties. He published his first story at age forty-five. He published his first novel, *The Big Sleep*, at age fifty. Early in the process, he purchased an empty address book and began entering character names that occurred to him. In another notebook he collected titles. He also collected police, crime, and underworld slang and he composed one-liners, sentences like "He wanted to buy some sweetness and light and not the kind that comes through the east window of a church."[†] He took detailed notes on people's clothing.

The poet David Wagoner[‡] speaks of how changing his process of composing into stages, beginning with a gathering stage, served his work. "In writing a poem I had tried

[*] Tharp, *The Creative Habit*, 80.

[†] Tom Hiney, *Raymond Chandler: A Biography* (New York: The Atlantic Monthly Press, 1997), 73.

[‡] "David Wagoner" in Nick O'Connell, *At the Field's End: Interviews with Twenty-five Northwest Writers* (Seattle: Madrona Publishers, 1987), 42–43.

simultaneously to be the dreamer, the explorer, the poet and the critic—all at once. As soon as I divided those into three stages, everything changed. I allowed myself to be crazy and very free in working, and then tried to make a poem out of the raw materials, and then criticized the poem after that." Wagoner begins his day by typing rapidly without thinking much, a free-association type of thing. He next looks at the sheets to see if there are any usable images or ideas. He also spends time collecting language. He's an avid birdwatcher and knows the names of hundreds of birds. Bird names constitute part of his resource base in the language.

Novelist Ian McEwan keeps a plot book. It is, according to Daniel Zalewski's *New Yorker* profile, "an A4 spiral notebook filled with scenarios."* He writes down story ideas, just two or three sentences on each. The notebook stores his ideas while his mind plays with them. Eventually, *never rushing* from notebook to new project, he takes one up and begins on a new novel.

The painter Gordon Wood makes intricate, brilliantly colored paintings and collages utilizing both traditional and digital means. His works, which fuse abstraction and figuration, engage extensively with nature and our place in it. They evoke, at one and the same time, the cosmos and the atom, the vast and the minuscule, the universe and the quark, birth and death. His gathering process involves extensive reading in science and philosophy. It involves hiking and camping in the Cascade Range, located near his Seattle home. There he enjoys and contemplates—often with his young

* Zalewski, "The Background Hum: Ian McEwan's Art of Unease," *The New Yorker*, February 23, 2009. McEwan's website may be found at *www.ianmcewan.com*.

son—forests, alpine meadows, glaciers, and the night sky unblotted-out by urban light. He also studies images on the Internet and manipulates them in Photoshop, and he takes notes on thoughts and ideas. Despite all this, the greater part of his creative process takes place in the studio, working on the work itself, which is, he says, "time-consuming, complex, and laborious."[*]

My own gathering practice has deepened as a result of a Saturday course I took recently in Writing Poems on Place offered by visual artist and poet Carletta Carrington Wilson.[†] Wilson invited us to bring a blank scrapbook, maps, colored pencils or markers, and an object or two connected to the place we were thinking of, in my case the Skagit River. This does appeal to my kindergarten nature, and I've fully adopted the scrapbook idea. My scrapbook on the Skagit contains lists of plants (cattails, skunk cabbage), lists of creek names (Red Creek, Coal Creek), and tributary river names (the Sauk, the Suiattle), maps, photos, and my own drawings—inept as they may be. I entered quotes by people like Jack Kerouac, who spent time meditating on the riverbank of the Skagit. I wrote down questions about the place. I pasted in pictures of the wild salmon that run on the Skagit—chinook, chum, pink, sockeye, and coho. The whole time I was working on my piece on the Skagit, I played with my scrapbook. After I completed the piece, there were scrapbook pages left over, so I continued using it for the next river in my series of river pieces, the

[*] Gordon Wood written communication with Priscilla Long, July 9, 2014, in possession of Long, Seattle. Wood's website may be found at *www.gordonwoodart.com*.

[†] The website of this visual and literary artist may be found at *www.carlettacarringtonwilson.com*.

Duwamish River. This was almost too much fun.

About this *gathering* business, sometimes known as research: Do not gather for too long before beginning to work on the piece. The best way is to begin gathering and to begin composing at the same time. The two activities exist in a dynamic relationship. The work itself points to what it requires. The gathering process can continue until the piece is done, but if you gather for too long before beginning to work on the actual piece, the dynamic relationship will never begin.

Questions to Contemplate as You Continue Your Practice

Do you spend part of your work time consciously gathering, consciously dabbling and doodling, collecting, ruminating? Are there ways you could deepen your art practice and make it more pleasurable by putting into place a gathering phase, one that continues as composing begins? What sort of materials might you gather and where might you keep these materials?

If you are one of those creators who loves research, do you work on the actual composition—whether poem, painting, or film—at the same time that you continue doing research? Is the composing phase in sync with the gathering phase, or do you continue to do research for days or years without working on the work itself? Can you improve your practice in this regard?

III.

OPENING THE PROBLEM, CLOSING THE DOOR

I like to have a lot of material lying about the studio for a long time—even for years—so that I feel intimate with each piece. An idea comes and the right piece of wood or stone—the absolutely right piece—must be found for it"

—Barbara Hepworth, sculptor

Upon beginning a piece, the "problem" of the work is still wide open. What will its shape be? What is the quest, what are the questions? What currents from history or mythology or philosophy or science or auto mechanics will flow into it? What materials will be used? How big will this monster be? The beginning is the thickening time, the discovery time, the dabbling time. It's the time to just put in time. Artists, creativity studies say, are able to tolerate ambiguity.* This is the time of über-ambiguity.

* John Briggs, *Fire in the Crucible: Understanding the Process of Creative Genius* (Los Angeles: J. P. Tarcher, 1990), 202–203.

It may or may not be a time of solitude. Many writers go to "writing practice," where they sit at a common table and write to a timer and then read (with no critiquing) to each other; some painters and visual artists work in the company of other visual artists. Still it's an exploratory time, an inward-turning time. It's the wrong time to critique, including internal critiquing, derogatory or ironic comments from one's own inner voices.

At this point, an external, outward-looking, audience-focused orientation works against the work. Hoping to please the crowd or some mentor or gatekeeper or hoping to make a pot of money or win some prize makes for a conventional piece of work or else for hack work. It's not until a later point, when the work is far along, that it benefits from its first viewings or readings, from the *critical* eye of its maker and of peer artists.

In an interview, the novelist and poet Jack Remick said, "When I lead workshops or give talks on writing, I joke that writers have just three problems: How to start, how to keep going, how to finish. If you solve those three issues, you've got it made. In a roomful of writers, that usually gets a laugh. Then I get serious—the most challenging aspect of writing is learning to take the time. Most writers are in a big rush to get published and so they let the work go too soon. It then comes back at them—all those story holes, all those weak characters, all the bad sentences—and they feel terrible. Once writers master the need to be loved—which means getting the work out so people will read it, review it and tell them how wonderful they are—they can dive into the myth and bring back powerful tales with teeth and lasting power. But letting

the work go too soon is the nemesis of the writer."*

The art-weaver Joan Potter Loveless reflects on her intent to keep the problem open as she begins a new tapestry: "My energy is high ... and the shapes I'm working on are beginning shapes and could go anywhere. Also, my mind plucks at this and that string to avoid finalizing the shapes I'm working on too soon, to keep the choices open and let the paths the weaving takes remain free for longer—to find the *other* alternative, the not-yet-seen way My mind in its flight sees my lovely granddaughter, Rochelle, and a tapestry for her begins. I see a kind of veiled surface rising, a surface of naturals ... and, as though the weaving is a web, I part it here and there and rounded shapes appear in the openings, perhaps clear light blues, the lovely unknown of her life Now I know I've started to weave again As I work, a wonderful thing is happening which I didn't know I was missing."†

The beginning of working on a piece is the time to consider the work itself, alone. This is as true of commissioned work as it is for work whose destination is unknown. The Swiss artist Méret Oppenheim told a parable about a Chinese craftsman commissioned by the emperor to make a carillon stand for a temple. The resulting artwork was so beautiful it looked as if it had been made by magic. The craftsman explained that after receiving the commission, he had wandered in the woods for eight days to forget it was from the emperor, then wandered another eight days to forget the fame that would be his, yet another eight days to

* Interview with Jack Remick, Reading and Writing Addiction blog, February 5, 2014 *(readinwritin.blogspot.com/2014/02/interview-with-jack-remick-author-of. html?spref=fb)*.

† "Joan Loveless, Weaver," in *Joan M. Erikson, Wisdom and the Senses: The Way of Creativity* (New York: W.W. Norton, 1988), 146–147.

forget the money to be earned. At that point he found the right piece of wood. "You see," Oppenheim said, "only then [did he] he set about his work. If you think about things like, 'I'm going to make this thing and sell it for three thousand dollars,' that's the end. You cannot work like that."[*]

In the beginning you open the creative problem, in terms of both its form and content. Do not rush. Do not think of the rewards it will bring or of how good or bad it will turn out. Keep the problem open for a good long time. Creativity researchers Jacob Getzels and Mihaly Csikszentmihalyi studied art students at the School of the Art Institute of Chicago and found that the ability to keep a problem open without preconceived notions or hasty foreclosure predicted a more original result. "Artists who defined their problem soon after starting to work," they reported, "produced drawings that were less original than those who kept the problem open longer. It seems that a creative problem cannot be fully visualized in the 'mind's eye'; it must be discovered in the interaction with the elements that constitute it. Delay in closure helps to ensure that the artist will not settle for a superficial or hackneyed problem."[†]

Hasty foreclosure signals performance anxiety. "Will I be any good? Will this be good or will it be a piece of crap?" Here's where our habit of discipline is our ally—the discipline to put aside anxiety, to sink into the work, to keep the problem open, to have faith in the process of making art.

[*] "Interview with Méret Oppenheim in Estrablatt May 1981 by Anna Blau" in *Méret Oppenheim: A Different Retrospective* (Zurich/New York: Edition Stemmle, 1997), 40.

[†] Jacob W. Getzels and Mihaly Csikszentmihalyi, *The Creative Vision: A Longitudinal Study of Problem Finding in Art* (New York: John Wiley & Sons, 1976), 247.

Questions to Contemplate as You Continue Your Practice

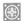 **Do you find yourself thinking of results too early in the process?** Does anxiety infect your work process? Do you spend time experimenting or do you find yourself in too much of a hurry? Could you slow down? Could you fertilize your creative work by experimenting more? If you have achieved a measure of success that brings pressure from buyers, editors, gallery owners, an agent, or the like, is there a way you can push that pressure away, return—perhaps during designated work periods—to a time when no one cared what you did?

 Might you take an hour to work on a piece you have in progress, with the rule that this hour is to dibble-dabble, to play, to speculate, to chew, to cogitate? For this hour, no results will be desired and none will be permitted.

 If you are trained as a commercial artist or as a journalist—trades in which audience is near to being the first consideration—can you generate a private project or two that you can work on for a good long time without regard to outside opinion?

IV.

FINDING AND
INVENTING FORMS

*He who cannot draw on three thousand years is
living from hand to mouth.*[*]
—Johann Wolfgang von Goethe, poet and philosopher

THE BEGINNING TIME, the mulling and dabbling time, the receiving-from-the-universe time is the time to consider not only content but form. Working into a form is manageable; working into thin air is not manageable, or not for long. Forms make a frame and provide liberty within the frame. Are you writing a sonnet or a mystery novel? Painting a mural on a brick wall? Composing a symphony? Each has conventions and a structure on which to build. Such traditional forms have mutated over the years. They provide a blueprint but in no way dampen or preclude the artist's own unique vision.

Forms abound. They can be discovered or invented.

* Goethe quoted in Tharp, *The Creative Habit*, 114.

Consider the triptych—a form that originated in early Christian art. It has three panels, each about the same size, or sometimes, two smaller outside panels that close to cover the larger center panel. (Early triptychs were sometimes used as private altars, opened for contemplation during meditation or prayer and otherwise kept shut.) The three panels are visually and thematically related.

The triptych is not uncommon in the visual arts and it has also morphed into a literary form. Its literary form asks for three blocks of type, about the same size, not large, thematically related. An example is "Three Yards," by Michael Dorris.[*] "Three Yards" is a memoir of the yard of Dorris's childhood, the yard he looked out upon as a lonely young man, and his yard as a married man with children. Dorris's triptych (with three sections) compresses a large amount of life into a tiny space—about 375 words. The dynamic relationships among the three "panels" allows for a common theme, minus the demand for narrative connective tissue.

Choosing to work in a form that interests you and allowing the content to follow is a good way to generate a new piece or pieces. The poet Ronald Wallace, facing a severe dry spell, decided out of desperation to write a sonnet a day for a year. It was, he wrote, "an exhilarating, if exhausting, experience. I wrote more than 400 sonnets that year, 200 of which were eventually published in literary magazines and 100 of which appeared as my book *The Uses of Adversity*."[†]

[*] Michael Dorris, "Three Yards," in *In Short* ed. by Judith Kitchen and Mary Paumier Jones (New York: W. W. Norton & Co., 1996), 203–205.

[†] Ronald Wallace biographical entry in *The Best American Poetry 2009* ed. by David Wagoner (New York: Simon & Schuster, Inc., 2009), 194; Ronald Wallace, *The Uses of Adversity* (Pittsburgh: University of Pittsburgh Press, 1998).

A form need not be traditional. Consider a form derived from the much-anthologized poem by Wallace Stevens titled "Thirteen Ways of Looking at a Blackbird." I wrote a creative nonfiction piece titled "Thirteen Ways of Looking at a Fur-Covered Teacup,"* the teacup referring to the Swiss artist Méret Oppenheim's famous surrealist object exhibited in 1936 at the Museum of Modern Art. My "Thirteen Ways ..." has thirteen sections, each with two parts that juxtaposed the weirdly synchronous lives of Wallace Stevens and Méret Oppenheim, who were unacquainted contemporaries.

In the process of composing my "Thirteen Ways ..." I discovered at least a dozen other short literary works titled "Thirteen Ways of ..." all in debt to Stevens's poem, each unique and interesting in its own way. Stevens, in his earlier turn, was looking at Asian art, including haiku. Art comes from art.

Stevens's "Thirteen Ways of Looking at a Blackbird" inspired visual artist Michael Spafford to make thirteen woodcuts, one for each of the poem's stanzas. He executed one set in 1975 and a second set, using the same sized panels but different images, in 1986. These homages to the poem are, in the words of art critic Regina Hackett, "not the usual echo. They are a duet with Stevens, a point/counterpoint."†

What about an abecedarian, that twenty-six-section form that begins with A and ends with Z? The English writer

* Priscilla Long, "Thirteen Ways of Looking at a Fur-Covered Teacup" in *Fire and Stone: Where Do We Come From? What Are We? Where Are We Going?* (Athens: University of Georgia Press, 2016).

† Regina Hackett, "Wallace Stevens/Michael Spafford—13 Ways of Looking at a Blackbird," April 24, 2009, ArtsJournal Blogs (*www.artsjournal.com/anotherbb/2009/04/wallace_stevensmichael_spaffor.html*).

William Boyd[*] has composed several: one a portrait of the artist Michael Andrews, one a portrait of a neighborhood in London. The writer Dinty Moore made an abecedarian about fathers titled "Son of Mr. Green Jeans."[†] I adore working in the form and have so far made three: "My Brain on My Mind," "O Is for Old," and "Autobiography: An A–Z."[‡] It's a stimulating and structured way to approach a big subject such as neuroscience or one's own autobiography. It's a welcome harness, but it also sets up an odd randomness: What other form could invite me to begin an autobiographical essay with my Arrests?

In any creative domain, there are many traditional forms. In poetry, for example, there is the sonnet, the sestina, the villanelle, the haiku, the haibun, and the ghazal, among others. To choose a form—a sonnet, say—gives you a map: fourteen lines and a big turn, probably after line eight. You can choose or eschew one of the two traditional rhyme schemes. Forms can be broken out of. The artist chooses the way to go.

Or you can invent a form. One way is to consider the shape suggested by the material you are working with. For instance, I am one of nature's clones (an identical twin). I became interested in composing a piece containing both scientific and personal elements about the Human Genome Project. The shape of this genetics-based piece, which I called "Genome Tome,"[§] came from the fact that we have twenty-three pairs of chromosomes (the biological structures that carry our genes).

[*] William Boyd, *Bamboo* (London: Penquin Books, 2005).

[†] Dinty Moore, "Son of Mr. Green Jeans," *Harper's Magazine* (January 2004).

[‡] Long, "My Brain on My Mind," and "Autobiography: An A–Z" in *Fire and Stone*; Long, "O Is for Old," *Post Road Magazine* Issue No. 24 *(www.postroadmag.com/24/folios/long.phtml).*

[§] Long, "Genome Tome" in *Fire and Stone*..

This suggested the form: twenty-three short "chapters," each with a title. From early on I knew I had to fill twenty-three bowls (as I thought of them, lined up in front of me). It was a challenging piece that took me three years to complete. It ended up appearing in *The American Scholar* and the next year received a National Magazine Award in feature writing.

One way to invent a form is to cross artistic boundaries. Twyla Tharp speaks of a breakthrough that came about as she was choreographing a silent dance called *The Fugue*. She was studying the fugal structure of Bach's *A Musical Offering*. She writes, "I began to see the logic in Bach's majestic notes, how he would take a phrase and reverse it, or invert it, or switch it from the right hand to the left, or reverse the inversion. It struck me that, given the symmetry of the human body and how its joints function, you could do the same thing with dance steps."[*]

Or you can make an artwork by using a form that has nothing to do with art. Eduardo Galeano's[†] book *Children of the Days: A Calendar of Human History* takes its form from the calendar. It has a chapter for each day of the year, 365 short chapters that each run a page or less. Each chapter is titled by a date and has a second title related to that day's specific content. For instance, October 18: "Women Are Persons" recounts that on that day in 1929, "the law acknowledged for the first time that the women of Canada are persons." The chapter goes on to inform that women already thought they were persons but the law did not. Galeano's structure provided a clear map (the days of the year) within which he was free to

[*] Tharp, *The Creative Habit*, 198–199.

[†] Eduardo Galeano, *Children of the Days: A Calendar of Human History* trans. by Mark Fried (New York: Nation Books, 2013).

draw on all of history for his facts and stories.

Antonio Vivaldi's *The Four Seasons* (1720) comprises a set of four violin concertos, one for each season. The painter Barnett Newman's *The Stations of the Cross* (1958–1966) comprises five large painted canvases, one for each of the traditional Christian stations of the cross. Then there's the Fibonacci mathematical sequence in which each number is the sum of the two preceding ones (1, 1, 2, 3, 5, 8, 13, 21, 34, 55, etc.).* The poet John Frederick Nims devotes several pages of his brilliant book *Western Wind: An Introduction to Poetry* to how architects, painters, and poets have used the proportions suggested by this strangely common-in-nature series of numbers to produce works. We can use them too.

* John Frederick Nims, *Western Wind: An Introduction to Poetry,* Second Edition (New York: Random House, 1983), 312–325.

Questions to Contemplate as You Continue Your Practice

 What artworks might you study outside the traditions of your own artform? If you are a visual artist, what could you do with the shape of a sonnet? If you are a poet, can you write a painting? (Poems derived from particular paintings are known as ekphrastic poems. In composing an ekphrastic poem, be sure to keep a record of the painter's name and the name and date of the painting.)

 What traditional forms within your own domain might you return to, not to recreate old forms, but to explore the relevance of their moves to your new work (in painting, for instance, you might return to painting on a square canvas or to dripping paint or scraping it; in poetry you might try the pantoum or you might try working in couplets).

V.

FEELINGS ARE
UNIMPORTANT

The first attempts are absolutely unbearable.[*]
—Vincent van Gogh, painter

I'VE LEARNED that when I'm in the middle of working on a piece, my feelings are best ignored. There are times of feeling excited, hopeful, energized. There's the deep discouragement of the middle. *What a mess. Ugh. This will never be any good. What was I thinking.* Then, toward the end, when a new piece is finally working out—elation. These feelings are predictable, inevitable, and irrelevant. What if I worked when I felt elated and stopped when discouraged? I would quit in the middle of every poem. My abecedarians would all crash at D for Doldrums. It's okay to feel the feelings. It's okay to vent them in your journal. But to let them guide your actions—not okay. As Robert Fritz puts it in *Creating*, "Your feelings are

 * Vincent Van Gogh to Ridder Van Rappard, in *The Creative Process: Reflections on Invention in the Arts and Sciences* ed. by Brewster Ghiselin (Berkeley: University of California Press, [1952] 1985), 47.

irrelevant to the creative process."*

What is relevant, though, is our *awareness* of the irrelevance of the feelings. In the middle of a big piece, when it all seems pretty hopeless, it's important to find the small next step or steps. This might be correcting a typo. It might be working on a sentence. Globalizing—thinking of the thing as a whole—doesn't work. I've found it useful during periods of frustration and discouragement to set a timer and limit the amount of time I work on this particular piece—fifteen minutes or at most an hour. Do the best job you can in that time and then quit and move on to another project. The next day, return for a short time to the knotted piece.

The greatest artists fall into despair about their work from time to time. Joan Miró spoke of his years as a young painter, post-academy: "I do not have the plastic means necessary to express myself; this causes me atrocious suffering, and sometimes I bang my head against the wall, from despair Still, passion and faith keep me going."† He spoke of a later time, after he'd gained control of his means, while painting a picture titled *The Farm*: "Nine months of constant hard work! Nine months of painting every day and wiping it out and making studies and destroying them all During the nine months I worked on *The Farm* I was working seven or eight hours a day. I suffered terribly, horribly—like a condemned man."‡ But his suffering did not deter him from working. Not one bit. He kept on. He was attempting to compress into *The Farm* everything that his homeland of Catalonia meant to him. A tall order. Eventually he succeeded. The writer Ernest

* Fritz, *Creating*, 300.

† Joan Miró in *Joan Miró: Selected Writings and Interviews*, 110.

‡ *Ibid.*, 93.

Hemingway purchased the painting and today it may be seen at the National Gallery of Art in Washington, D.C.

Is there an artist in existence who does not, at one time or another, fall into the deep well of discouragement? Discouragement and lack of confidence are no fun but they need not sabotage your working process. Do not permit this. Just keep working. Miriam Schapiro, feminist art pioneer and leader of the Pattern and Decoration movement, wrote, "When I look back on the years of excessive self-doubt, I wonder how I was able to make my paintings. In part, I managed to paint because I had a desire, as strong as the desire for food and sex, to push through, to make an image that signified."*

In the end, what mattered was not how she felt but what she did. And so it is with us.

* Miriam Schapiro. "Notes from a Conversation on Art, Feminism, and Work" in *Working It Out: 23 Women Writers, Artists, Scientists, and Scholars Talk About Their Lives and Work* ed. by Sara Ruddick and Pamela Daniels (New York: Pantheon Books, 1977), 303.

Questions to Contemplate as You Continue Your Practice

Do you find your work process overly influenced by your feelings? Are there times when your feelings sabotage your work? Does your energy for working rise and fall according to your cycle of hope and discouragement?

Do you have way too many unfinished works? In what ways could you develop more resilience, a more steady and unflappable approach to working on your art?

VI.

ACQUIRING SKILLS, MASTERING DOMAINS

The Louvre is the book in which we learn to read.[*]
—Paul Cézanne, painter

"WHAT YOU CREATE should be determined by your needs, not your weaknesses,"[†] writes the painter Anna Held Audette in her tidy guidebook for painters, *The Blank Canvas: Inviting the Muse.* If you are terrible at drawing hands, do you shun hands in favor of faces or sheep? If, instead, you plunge in and train yourself to draw hands, then you are free to make creative choices according to your impulses, inspirations, and desires, rather than according to what you are staying away from due to lack of skill in that area.

In the early years of an artist's development, an enormous amount of skill-mastery takes place. One becomes a cognoscenti of a domain, defined by creativity researcher

[*] Paul Cézanne quoted in Anna Held Audette, *The Blank Canvas: Inviting the Muse* (Boston and London: Shambhala, 1993), 68.

[†] Audette, *The Blank Canvas*, 92.

Mihaly Csikszentmihalyi[*] as a set of symbolic rules and procedures. The visual arts are a domain or, tuned finer, painting is a domain, sculpture is a domain.

Perhaps your first art education took place within an institution, say an MFA program, a certificate program, or a series of adult education courses. After completing the degree or the courses, the goal is to keep working, to keep learning, to keep producing. In their insightful book *Art & Fear*, David Bayles and Ted Orland write that 98 percent of art majors do not go on to become artists due to the fact that there is no longer any *destination* for the art graduate's work, no longer the weekly critique, no longer the professor or the fellow art student to comment, no longer the organized routine and deadline, no longer anyone to see the work or even to care.[†] Bayles and Orland suggest finding a friend or friends in art, and they suggest that you quit thinking about MoMA (the Museum of Modern Art) as a destination for the painting you are working on. Think local. Think small. Just keep working.

Or perhaps you are self-taught, that is, perhaps you learned without formally entering some school or program. As a young man, Alberto Giacometti once spent nine months in Rome and Florence filling sketchbooks with copies.[‡] A musician who knew Bob Dylan as a teenager described him as "blotting paper." "He soaked everything up. He had this immense curiosity; he was totally blank and ready to suck

[*] Mihaly Csikszentmihalyi, *Creativity: Flow and the Psychology of Discovery and Invention* (New York: HarperCollins Publisher, 1996), 27–28.

[†] David Bayles and Ted Orlando, *Art & Fear: Observations on the Perils and Rewards of Artmaking* (Santa Cruz: The Image Continuum, 1993), 10–12.

[‡] Sylvester, *Looking at Giacometti*, 149.

up everything that came within his range."[*] In his memoir, *Chronicles*, Dylan speaks of a Robert Johnson blues recording he'd been given: "Over the next few weeks I listened to it repeatedly, cut after cut, one song after another, sitting staring at the record player …. I copied Johnson's words down on scraps of paper so I could more closely examine the lyrics and patterns …." Indeed most of *Chronicles* chronicles the ways in which Dylan deeply absorbed the folk music of the American past up to his own.[†]

Patti Smith[‡]—poet, singer, performance artist, writer, and visual artist—grew up immersed in books. She absorbed the work and admired the lives of artists from Lewis Carroll to Arthur Rimbaud, from William Blake to Mickey Spillane. A great performance artist, she absorbed the moves of predecessor performance artists, especially Mick Jagger of the Rolling Stones and Bob Dylan.

While teaching himself to write, Raymond Chandler would read a story he admired and then rewrite it in his own words. He would then reread the model to check it against his pastiche, the better to learn its moves. He learned plotting from Erle Stanley Gardner (although plotting, according to Tom Hiney's biography of Chandler, interested Chandler considerably less than it did Gardner).[§]

Theodore Roethke wrote down by hand in notebooks

[*] Lewis Hyde, *Common as Air: Revolution, Art, and Ownership* (New York: Farrar, Strauss and Giroux, 2010), 197, 198.

[†] Bob Dylan, *Chronicles* (New York: Simon & Schuster, 2004).

[‡] Victor Bockris and Roberta Bayley, *Patti Smith: An Unauthorized Biography* (New York: Simon & Schuster, 1999); Patti Smith, *Camera Solo* edited and with interview by Susan Lubowsky Talbott (New Haven: Yale University Press and Wadsworth Atheneum Museum of Art, 2012).

[§] Tom Hiney, *Raymond Chandler: A Biography* (New York: The Atlantic Monthly Press, 1997).

more than 1,200 poems written by other poets, which he transcribed as an aid to memorizing them. He often said, "You can't remember a poem unless you write it down."[*]

In the life of an artist or poet, the beginning is only the beginning. Learning continues. Artists immerse their lives in art, studying this artist then that one, not necessarily artists working in the same medium. Words may creep into a painter's paintings. Poets may develop a color palette. "End of summer," goes a poem by Muriel Rukeyser, "Dark-red butterflies on the river/ Dark-orange butterflies in the city."[†]

Many artists work in more than one discipline, though one may be more serious, the other more a form of play. The painter and sculptor Joan Miró composed poems. The jazz musician Miles Davis painted. The visual artist Faith Ringgold writes children's books. The painter Françoise Gilot composes poems. The musician Bob Dylan paints and draws. The novelist Henry Miller painted. "Painting refreshes and restores me," Miller wrote in *To Paint Is to Love Again*. "It enables me to forget that I am temporarily unable to write. So I paint while the reservoir replenishes itself."[‡]

Throughout an artist's lifetime, works by other artists both living and dead keep chattering away; the dialogue continues. You are never finished with learning.

The context of present-day art is past art. Françoise Gilot wrote, "In the summer of 1962 I chartered a yacht belonging to friends and sailed with my children and a crew of three into

* Allen Seager, *The Glass House: The Life of Theodore Roethke* (New York: McGraw-Hill Book Co., 1968).

† Muriel Rukeyser, "Breaking Open," in *Out of Silence: Selected Poems* (Evanston, Illinois: TriQuarterly Books, 1992), 146.

‡ Henry Miller, *To Paint Is to Love Again* (Alhambra: Cambria Books, 1960), 21.

the Aegean Sea While there, the classic Greek myths were often on my mind, especially the story of Theseus [who must enter the labyrinth and kill the Minotaur, the monster at the center, or be eaten by him. Theseus kills the monster and finds his way out by following a string given to him by the Princess Ariadne]. After our return [Gilot continues] I devoted the rest of 1962 and all of 1963 to the pictorial development of about fifty canvases in the 'Labyrinth' series. There was nothing descriptive in these paintings—only structures, rhythms, and colors that by themselves evoked the different phases of the legend and also its multifaceted meanings as envisioned by Theseus, Ariadne, or the Minotaur. What interested me was to see the myth from an androgynous point of view where all the characters were just the different aspects of one person, namely the painter." The ancient drama lives on, with its current artist transforming its shapes and meanings.

Jack Remick composed his novel *Blood* in 120 sections, each of which he originally wrote in half-hour writing-practice sessions. He took the inspiration and skeletal form of *Blood* from *The 120 Days of Sodom,* the fiction composed by the Marquis de Sade while the marquis was imprisoned in the Bastille during the French Revolution.† *Blood* is quite different from *The 120 Days of Sodom*, it being immersed in our own time, but it shares the 120-chapter structure, sodomy, the dungeon, the point of view of the killer, and the musical chairs of good and evil.

In her "Collaborations" series Miriam Schapiro honors the predecessor painters who made her own work possible.

* Gilot, *An Artist's Journey*, 78.

† Jack Remick email to Priscilla Long, February 22, 2014, in possession of Long, Seattle.

"I am an artist looking for legitimate ancestry," she said in 1977.[*] In lush, brightly colored works composed mostly of acrylic and fabric on canvas, she honors Frida Kahlo, Sonia Delaunay, the Russian artists Natalia Goncharova, Varvara Stepanova, Lyubov Popova, and other virtuoso women painters of the past.

"My friends were the masters," wrote Henry Miller. He was not acquainted with the painters, but he did know their work. "I lived with them [the paintings] as Balzac did with the empty frames which adorned the walls of his Passy home in the days when he had nothing but debts and an unlimited imagination."[†]

Whether or not your early training is formal or informal, it's only early training. Learning continues. Artists are the supreme autodidacts. They are autodidacts quite apart from whatever formal education they did or did not enjoy. They never stop learning.

One strategy I use is to occasionally take a class from one of my peer artists. I take classes in which the point is to generate new work, not to critique work, since that would be asking the carpenter to pound nails on holiday. (When I *take* a writing class, as opposed to *teaching* one, I consider myself to be on holiday.) And too, other writing teachers often take classes I am teaching.

[*] Thalia Gouma-Peterson, *Miriam Schapiro* (New York: Harry N. Abrams, Inc., 1999), 123–141.

[†] Miller, *To Paint Is to Love Again*, 19.

Questions to Contemplate as You Continue Your Practice

🔘 **Whose work are you looking at?** Do you go outside your own genre to look and to learn? What are you reading? What new directions are igniting your imagination? What craft moves or new approaches are you dipping into? Have you done anything new lately?

🔘 **Do you have a hobby or interest**—perhaps playing a musical instrument or cooking or dancing—that both refreshes and feeds your creative work? Or do you in fact work in more than one genre?

🔘 **How do you go about systematically deepening your craft skills?** Could you do more?

🔘 **Is there a class you might take,** whether in your own area of work or in a completely different area, that might stimulate and inform your own working process?

VII.

CREATIVITY HEURISTICS
FOR ARTISTS

What if imagination and art are not frosting at all,
but the fountainhead of human experience?
—Rollo May, psychoanalyst

Creativity studies[†] within the discipline of sociology and psychology have burgeoned since the 1950s and at this point quite a lot about creativity—in our terms, doing creative work—is known. Most popular books on the subject assure the reader that creativity can improve anyone's life and especially anyone's business, and that the practice of ramping up one's creativity is not just for artists. Fine, but why

* Rollo May, *The Courage to Create* (New York: Bantam, 1975), 150.

† Influential studies and accounts from the past fifty years include Teresa M. Amabile, *Creativity in Context* (Boulder: Westview Press, 1996); Csikszentmihalyi, *Creativity* (New York: HarperCollins Publishers, 1996); Csikszentmihalyi, *Flow: The Psychology of Optimal Experience* (New York: Harper & Row, 1990); Briggs, *Fire in the Crucible*; Vera John-Steiner, *Notebooks of the Mind* (Albuquerque: University of New Mexico Press, 1986); Howard Gardner, *Creating Minds* (New York: Basic Books, 1993); Mara R. Witzling, *Voicing Our Visions: Writing by Women Artists* (New York: Universe, 1991); Cindy Nemser, *Art Talk: Conversations with 15 Women Artists (New York: HarperCollins, 1995).*

shouldn't we artists and writers look at creativity heuristics to see whether one or more suggested practice could streamline or deepen our own working methods?

Here are some barebones principles, the ones I find most intriguing.

◈ Quantity

Quantity matters. Creativity studies have shown that artists who produce masterworks also tend to produce the most works, including the most duds.* Something to think about. Consider the writing habit of neurologist and many-book author Oliver Sacks: "I have kept six or seven hundred diaries," Sacks said in an interview. "Very few have been published. Very few are even worth publishing I write many, many things. I have written hundreds of case histories, but I have tried to publish fewer than 5 percent of them. Sometimes this is because I feel it would be indiscreet or perhaps offensive to publish these things. Sometimes I cannot finish them; I do not know how to resolve this problem, and so, in the end, only a little of writing sees the light."† Sacks's incessant writing created the resource base out of which his numerous published works emerged.

◈ Noting and Observing the World.

Not seeing is a habit. Seeing is a practice. Today most

* D. K. Simonton, "Creativity from a Historiometric Perspective," in *Handbook of Creativity* ed. by Robert J. Sternberg (Cambridge: Cambridge University Press, 1999), 122–124.

† Eduardo Punset, "The Hidden Self": Interview of Oliver Sacks in *Mind, Life, and Universe: Conversations with Great Scientists of Our Time* ed. by Lynn Margulis and Eduardo Punset (White River Junction, Vermont: Chelsea Green Publishing, 2007), 95.

people walking down the street or riding the bus are peering into their devices. No one is looking out to notice a tree, a bird, or another person. We artists need to take real time to simply observe. This may be done by sketching the street or garden or coffeeshop (no matter that you are an abstract painter or a filmmaker or even a writer). It may be done by doing the Here and Now assignment—recording the street or garden or coffeeshop by writing continuously for a set time, no personal insights or conclusions, just what is in front of you, using all senses—eyes, ears, nose, skin, taste, proprioception (body sensations). If you are a writer, you might resort to the artist's sketchbook—nobody cares what your sketches look like. If you are a visual artist you might try writing the scene.

◉ The Lateral Move

In creativity studies, divergent thinking is much spoken of so let's speak of it here. To diverge, to make a lateral move, is to move sideways instead of plowing straight ahead.

Let's say you're writing the Cinderella story. Cinderella is the protagonist. She is oppressed, repressed, mistreated, 'buked and scorned, put down. Now if she forged straight ahead and fought back, she might go on strike or she might pour a cup of salt into the soup or she might burn the house down or she might run away. Instead, the storyteller gives her a helper, the fairy godmother. I would call the storyteller's introduction of the fairy godmother a lateral move. This new character drops in from nowhere, she's an intruder, and she changes everything. But she imposes a condition (return by midnight or turn into a pumpkin). Her arrival does not

constitute an exit from the bad deal (which would end the story). In dramatic story structure, the arrival of an intruder or a helper constitutes a lateral move.

Another way to move sideways is to accept the notion of random associations. You might open a dictionary and point to a word and then paint it or put it in your poem. You might go out to a shop and write down the first object you see and then put that screwdriver or purple candle in your painting or your poem. Now everything has changed. Now, as Surrealist artist Max Ernst put it, "The umbrella and the sewing machine will make love."* You proceed from this new place.

The Surrealist game Exquisite Corpse moves laterally. This is a collective way of making a poem or painting. Each person takes a piece of paper. The form, the order of moves, is agreed upon, such as Adjective, Noun, Verb, Adjective, Noun. First everybody writes an adjective on his or her paper, then folds it over to hide the word and passes it to the next person. Next everybody writes a noun, folds the paper, passes it on. The rule is that you cannot see what anyone else has written till the end. At the end everyone unfolds their paper and reads the sentence they find in their hands, written word by word by everyone in the room. Or, you can do it the visual art way. Everyone draws a head ... next, a torso

Or consider the Oulipo† group of artists who made works by imposing elaborate constraints, such as replacing each meaningful word in a text with its dictionary definition. Another is S+7, in which each substantive (noun) in a given text is replaced by a noun in a chosen dictionary that lies

* Max Ernst, "Inspiration to Order" in *The Creative Process,* ed. by Ghiselin, 60.

† *Oulipo Compendium* ed. by Harry Mathews and Alastair Brotchie, Revised and Updated (London: Atlas Press and Los Angeles: Make Now Press, [1998] 2005).

seven places down from the noun in question. Another is the Beautiful Outlaw. Every letter in the alphabet must be used in every line, with the exception of the corresponding letter in the person's name to whom the poem is addressed. In a poem addressed to Eva an *e* is left out of the first line, a *v* is left out of the second line, and an *a* is left out of the third line. This and much more is explained in *Oulipo Compendium* edited by Harry Mathews and Alastair Brotchie.

Does all this sound bizarre and a bit silly? These are techniques artists have devised to move sideways, to invite in the non-obvious, to create more associations, to generate ideas and create works, to think divergently.

Shift Your Focus to Identify with Each and Every Element

In Gestalt dreamwork, the dreamer speaks from the point of view of every element in the dream ("I am the road. I am constantly being walked upon"). This technique for gaining psychological insight can be useful for making art. Are you a novelist? Write (in your notebook) from the point of view of the antagonist, even if you will never, in the completed novel, be in his or her point of view. Are you a landscape photographer? Shoot from the point of view of the tiny sparrow in the scene (see the large-scale photographs of Jean-Luc Mylayne). A painter? Paint as if every object has equal value (which would lead you to something like Cubism). This is an idea to play with and it could lead anywhere.

◈ Apply the Conventions of One Domain to a Different Domain

I shaped a nonfiction piece about visiting the ruins of the farmhouse of my childhood the way professional archeology reports are shaped, with titled sections for different findings. "Archeology of Childhood" was the result.* Some painters— Janet Fish and Audrey Flack are examples—paint pictures that resemble photographs, only more so. The quilt artist Helen Remick has structured a quilt after a piece of music, and another using mathematical precepts.†

Artists who commonly work in more than one medium, such as the Seattle-based poet and visual artist M. Anne Sweet,‡ function within a space in which the two mediums inform each other. Poems get incorporated into visual artworks; visual images end up in poems. For Sweet, music is a third medium. Its influence on her poems intensified when she began performing poetry with the late visual artist and musician Chuck Smart.§ "The rhythm of my poetry changed ... becoming more syncopated," she writes. "Sometimes the words ride on top of the percussion ... and sometimes they become part of the 'song,' but always the hope is that the words and voice are another instrument within the ensemble, not that the instruments back up the voice. One interesting discovery was that some poems work better with a four-beat rhythm, while others work better as a six-beat rhythm."

* This piece won *The Journal's* William Allen Creative nonfiction prize (Spring/ Summer 2001). "Archaeology of Childhood" in *Fire and Stone*.

† To see Helen Remick's extensive body of work, go to *www.helenremick.com*.

‡ M. Anne Sweet email to Priscilla Long, May 2, 2015, in possession of Long, Seattle. For an overview of Sweet's work, go to *www.studiosixeight.com*

§ For an overview of Smart's life and work, go to *www.chucksmart.com*.

These are a few ways to play, to shift elements, to think and dabble and ruminate. To invite new combinations and inspirations.

Questions to Contemplate as You Continue Your Practice

- **Have you put into place or could you begin a daily practice of observation**—even if for five minutes—of writing or sketching what you perceive with your senses, whatever is directly in front of you?

- **Do you tend to work in the same way all the time?** Could you shake it up a bit, add a random element?

- **What would a lateral move mean in terms of a piece you are working on right now?**

- **What alternate domains** (spheres of activity or knowledge) might you investigate in order to get novel ideas, structures, directions?

VIII.

TAKING TIME, MAKING SPACE

Nobody will give you freedom. You have to take it.[*]
—Méret Oppenheim, visual artist

IMAGINATION DOES NOT FLOURISH under crowded conditions. Creators need space. A studio. Or just a corner closed to visitors. And creators need time. Uninterrupted time, time free of the telephone, email, Facebook, Twitter, too much to do. Space and time.

It's not the size of the space that counts. It's not the length of time. It's the sense of spaciousness. It's a feeling—space enough and time enough. If, on one day, you have only fifteen minutes or a half-hour, and if you can work within the given time with focus, then that is time enough for the time being. On another day there will be more time.

A timer is an artist's quintessential tool. It corrals a

* Acceptance Speech for the 1974 Art Award of the City of Basle, January 16, 1975, reprinted in *Méret Oppenheim: Defiance in the Face of Freedom* ed. by Bice Curiger (Cambridge: The MIT Press, 1989), 130.

boundary of time—four hours, one hour, fifteen minutes—in which to work, each and every day. Even in a life fraught with responsibilities such as a demanding job or the care of small children (or both), the determined artist can, with the help of a timer, get daily work time.

Even though you can make art anywhere, in the long run a studio or a study is not really optional. It can be an attic room or a basement room or any sort of room. The painter Emily Carr wrote in her journal, "I want a place I can be free in, where I can splash and sling, hammer and sing, without plaster tumbling. I think I want a warm barn."[*]

"First, clear a space," writes Pat B. Allen in her book *Art Is a Way of Knowing.* "You will eventually make a mess; where can you do this with ease? …. A dedicated workspace, however modest, confirms your intention and allows you to work when you have even brief moments without spending time setting up."[†]

Many artists rent studio space in the art-studio buildings established in a number of cities. Shaun McNiff first taught art-therapy in a studio known as the "Art Cottage" at a mental hospital. His Art Cottage "served as an alchemical vessel for the transformations wrought by the artistic process."[‡] Art needs an alchemical vessel, a space in which the artist can work.

The time and the space to make art must be free of impingements and interruptions. It's time and space in which to fiddle and doodle, experiment, tweak lines of a poem,

[*] Emily Carr quoted in *Carr, O'Keeffe, Kahlo: Places of Their Own* by Sharyn Rohifsen Udall (New Haven: Yale University Press, 2000), 228.

[†] Pat B. Allen, *Art Is a Way of Knowing* (Boston: Shambhala Publications, 1995), 12.

[‡] McNiff, *Art Heals,* 16.

sketch, dream. "Experimentation," writes Joan Erikson in *Wisdom and the Senses,* "which is time taking, is nevertheless a vital ingredient of learning. It can be playful and yet seriously increase the understanding of the material and the development of skillful hands. Each failure is a further step in the learning process."[*]

Time put in every day ties us to the threads we are weaving. It takes us to the zone that creative work comes out of. It reminds our unconscious mind of what we are working on. And on the days we have more time, we do not have to struggle to re-enter a territory we have not visited for days or weeks. We are right there. And, writes the poet Mary Oliver, "the occasional success, to the striver, is worth everything. The most regretful people on earth are those who felt the call to creative work, who felt their own creative power restive and uprising, and gave to it neither power nor time."[†]

The ceramics sculptor Patti Warashina had two children in her mid-twenties and by her late twenties was a single mother. She also taught art at Wisconsin State University. She maintained a state of high organization, and every day made a list of things she had to do. She put the girls to bed at 8:00, with an aquarium that had fish, a calming bubbler, and a night-light, and let them read in bed. She got ready for the next day, and then went down to her basement studio and worked until about 3:00 in the morning. She enlisted their support: "When the girls were very small, we had some very serious talks. I told them how important it was that I get

[*] Joan Erikson, *Wisdom and the Senses: The Way of Creativity* (New York: W. W. Norton & Co. 1988), 67.

[†] Mary Oliver, "Of Power and Time" in *Blue Pastures* (San Diego: Harcourt Brace & Company, 1991), 7.

my artwork done and teach so that I could support them. I think they took these conversations very seriously, as they were very dependable and responsible. They came home on time, locked the door, etcetera. They were latchkey kids It sounds like a rather rhythmic routine, but in actuality I would go to the studio every spare moment. A half hour here, a half hour there. My studio was always in a basement so I could just go downstairs to fire the kiln and yet be at home with the children. When the kids were small I took them down to the studio and let them play."

"I think of my studio as a vegetable garden," wrote Joan Miró. "Here, there are artichokes. Over there, potatoes. The leaves have to be cut so the vegetables can grow. At a certain moment, you must prune."

"I work like a gardener or a wine grower [Miró continues]. Everything takes time. My vocabulary of forms, for example, did not come to me all at once Things follow their natural course. They grow, they ripen. You have to graft. You have to water, as you do for lettuce. Things ripen in my mind. In addition, I always work on a great many things at once. And even in different areas: painting, etching, lithography, sculpture, ceramics."†

Looking around your workspace, can you see evidence of a "vocabulary of forms"? Thinking of creators—whether past or still living—that you've admired or learned from, can you perceive a "vocabulary of forms" they have developed? It's

* Patti Warashina quoted in Anne Mavor, *Strong Hearts, Inspired Minds: 21 Artists Who Are Mothers Tell Their Stories* (Portland, Oregon: Rowenberry Books, 1996), 26–27.

† "I Work Like a Gardener" by Yvon Taillandier (February 1959) in *Joan Miró: Selected Writings and Interviews* ed. by Margit Rowell, 250.

fascinating to look at photographs of artists in their studios with this question in mind. A 1942 photo of Piet Mondrian, the painter known for spare vertical and horizontal lines, squares and rectangles filled with primary colors, shows him standing in his apartment-studio.* All the lines are horizontal or vertical. In fact, Mondrian painted and arranged his living-working quarters to look like one of his paintings. The space mirrors the work, the work mirrors the space. This is one way to turn a workspace into an alchemical vessel.

The artist must sequester space and the artist must sequester time. Sequester: from the Latin *sequestrare*, to commit for safekeeping.

These days many artists and writers teach, either privately or within an institution. If you teach, you know that teaching is difficult, time-consuming work. How to teach and also keep your hand in your own creative work? As a teacher, my own trick for staying productive as a writer is to do every assignment I assign, to hand in my homework to the developing professional writers I teach, as they hand in their homework to me.

This practice serves my own creative work but it also serves my mentees, I think, in that it models being a writer up close. None of us need hand in perfect work but it must be the best we can do at the time, within the given time, and it must be professionally formatted. Later we revise, polish, reconsider, complete. And then we send it out.

Certainly, there are teaching situations that preclude distributing your work-in-progress to your students. But that

* The photo by Arnold Newman showing Mondrian in his studio at 353 East 56th Street in New York City appears in *Mondrian: The Art of Destruction* by Carel Blotkamp (London: Reaktion Books Ltd, [1994] 2001), frontispiece.

doesn't prevent you from doing the work you assign. Why would it? Must they write a short explanatory essay? Why not write a short explanatory essay? Must they compose a personal essay re: a key turning point in their life? Why not do the same? Hold to deadlines. This will keep you from becoming one of those weary tape recorders issuing instructions that said tape recorder has not actually carried out for years. You may be overworked, but part of the work will be your own art. Besides, doing your own assignments serves as an inexorable kick in the pants to make better assignments.

Time enough and space enough. Where I live—Seattle—the coffeehouse makes a great writing studio. At one of my best hangouts, the Fremont Coffee Company, I see other writers (we may say hello, but we don't talk), as well as a certain artist with colored pencils who works diligently in a sketchpad for hours at a time.

Consider getting up an hour earlier to get some time of your own. (Or stay up an hour later.) Consider applying for artist's residencies, where they give you time and studio space (and food). Consider meeting with a buddy for an hour or two each week, not to talk, not to critique, but to write or draw or paint in tandem.

Questions to Contemplate as You Continue Your Practice

⚙ **How well does your workspace serve the creative work that you do?** Is your studio cluttered with business matters, bills, or piles of other stuff you must get to? Is your workspace bulging with distractions? What is on the walls? How can you move it closer to being, in Shaun McNiff's words, an "alchemical vessel for the transformations wrought by the artistic process"?

⚙ **How do you sequester time to do your own work,** particularly during the busiest times when other demands impinge?

⚙ **If you teach,** how can you better shape your teaching so that it serves your own creative work as well as that of your students?

⚙ **Consider the painter Joan Miró's phrase "vocabulary of forms."** A vocabulary consists of separate elements that can be put together in various ways to make a whole. Words, obviously. In the work of a visual artist, certain shapes or images may reappear. In Miró's works, for instance, we see a recurring stringlike line that dances or floats or curls and becomes a head or a ray of sun or an eyelash or a star. In the writer Judith Kitchen's prose, we see a paragraph built from a sentence or two plus many fragments. A dancer has a vocabulary of gestures or moves. Look around your workspace. Look at your

poems or your pieces. Do you see a "vocabulary of forms"? How could the idea of a "vocabulary of forms" be useful to you as you go forward?

COMPLETING WORKS

There is a magical power in every completed, self-contained creation.[*]

—Peter Zumthor

What if it's totally embarrassing?
I only do it for myself.
What if it will expose my true nature as silly and stupid?
If my mother saw this she would never speak to me again.
How do I know if it's finished?
This subject matter bores me now.
I'm not looking for fame. I don't care.
What if it shows me up for the fraud I am?
This is stupid and dumb.
What's the point? There's no money in art.

These are all rationales—at times subconscious—for not completing a novel, for leaving piles of paintings half-finished, for never finishing that collage or that poem. They may also occur to artists who've become successful in one style or mode

* Peter Zumthor, *Thinking Architecture* (Basel: Birkhauser, 2010). 16.

and thereafter feel a certain reluctance to venture out into new creative territory. Being ignored or scorned following success is no fun. Yet the greatest artists are constantly venturing into new territory, risking failure and even ridicule.

How do you know when a piece in finished? For one thing, there's no simple rule, obviously. It's a judgment. If you seldom or never make the judgment, something is wrong. I think of completing a piece as a craft skill. Can you tell a brilliant opening from an average one? Can you tell a virtuoso sentence from an average one? Can you tell a resolved painting from a half-finished or abandoned one? Of course one's savvy increases as the years of creative endeavor roll on. But never declaring a piece finished is exactly the same as never finishing a piece. If you "finish" it, you might fail. If it's not done yet, it hasn't failed yet either.

The process of finishing a work typically overlaps with its first reading or viewing, its first public exposure to your peers or to your first (probably small) audience. At this point you may receive some useful feedback. Even with no feedback, the act of presenting *in itself* helps you to see work from the outside, to get distance from it. This in turn helps you see where to make necessary tweaks. Completing works and putting them out in the world is part of the *creative* process. The moment you become aware of its potential or actual audience is the moment you see touches and fixes it requires that you hadn't seen before. And once you've released it to the world, you've cleared room for new works. Time to celebrate. Time to cogitate the next piece.

And yes, there's such a thing as finishing a piece twice or three times. Time passes and you see something more you can

do. Poets have been known to revise a poem *after* publication. Is there such a thing as a novel that was finished the first time it was finished? Finishing is a process, sometimes a rather extended one.

Here's what finishing is *not*. It's not awaiting pats of approval from your workshop, teacher, mentor, agent, editor, or other power. The creator who waits for approval has suspended judgment and claims to have no way to judge. This creator believes that if it's accepted, it's good and if it's rejected, it's a piece of crap. This creator declines to make his or her own judgment.

This is a good way to never finish. It's a good way to stall. It's a good way to become one of those would-be writers or artists who might be remarkably talented but who never finishes anything.

To start a painting is to start a dialogue. So says the painter Gordon Wood: "In my relationship to my paintings the original conception has a path to the end, and along that path ... I explore and open a flowing vocabulary of symbolism, abstraction, representation, and integration of all components [and their] juxtapositions to convey the meaning of the imagery clearly All the while during the dialogue my imagination is being challenged to bring all the variables within my experience and the new unfolding artwork to a successful reciprocal and dynamic whole. When I see, hence think and feel there is nothing more I may contribute to this dialogue, and the image stands on its own, it is birthed so that it may go out in the world and continue this conversation

with others'" During the process others may interact and comment on the painting, but it's the artist's relationship with the work itself that evolves to an end point.

The writer Janet Yoder was asked in an interview how she knew when a piece was finished. She said: "When a piece is getting close, I read it aloud and listen for stumbles or for anything that feels off. Then I tweak the piece and read it again. If—after many rounds of tweaking and reading— the work flows and if it says what I want to say, then I will pronounce it finished."†

Note that Yoder will *pronounce* it finished. She will make a *judgment*. She will *decide*. No one else is doing the job for her.

How to arrive at that judgment? It is based on all the craft skill and critical acumen you have accumulated so far. Nothing more, nothing less. At first, the main thing is to do it. And then—do it again.

* Gordon Wood written communication with Priscilla Long, July 9, 2014, in possession of Long, Seattle. To see Wood's work, go to *www.gordonwoodart.com*.

† "Remick and Ray Interview Janet Yoder," March and April, 2014 Bob and Jack's Writing Blog (*bobandjackswritingblog.com/writing-with-discipline-2/remick-and-ray-interview-janet-yoder/*).

Questions to Contemplate as You Continue Your Practice

Are you good at bringing works to completion? Might this area of your art practice be improved?

Do you rely on others to inform you as to whether or not a work is finished? Are there ways you could become more self-reliant in this matter even as you also consider feedback?

X.

A Life in Art:
Peer Artists

You think you're alone and thought this up yourself
you know, and you're not; you're part of this
intricate web of twentieth-century thought. That
is, to me, incredibly lovely because it's just less
lonely.

— Laurie Anderson (1980), performance artist

MAKING ART can be a meaningful, spiritual, healing, deeply engrossing way of life whether done in the company of others or in isolation. Henry Darger, who died in 1973, is one who worked in isolation.[†] His story challenges the

* "Laurie Anderson" interview by Robin White (*View*, 1980), in *American Artists on Art from 1940 to 1980* ed. by Ellen H. Johnson (New York: Harper & Row, Publishers, 1982), 244.

† Henry Darger and Michael Bonesteel, *Henry Darger: Art and Selected Writings* (New York: Rizzoli International Publications, 2000); John M. MacGregor, *Henry Darger: In the Realms of the Unreal* (New York: Delano Greenidge Editions, 2002); Brook Davis Anderson and Michael Thevoz, *Darger: The Henry Darger Collection at the American Folk Art Museum* (New York: Harry N. Abrams, 2001); Holland Cotter, "A Life's Work in Word and Image, Secret Until Death," *The New York Times*, January 27, 1997, B7.

platitude that artists require community—the stimulating conversations, questions, challenges, and heartfelt support of peer artists.

Darger was orphaned at four and grew up in an asylum for the feeble-minded, from which he escaped at sixteen. He went on to spend his life as a recluse, living in rented rooms and supporting himself as a menial by cleaning hospital lavatories. When he died, his landlord discovered that "[f] or nearly fifty years, his tenant had been writing and painting almost ceaselessly but had kept the results hidden from the world." His work consists of more than 15,000 pages—a collaged, painted, and written epic, "part allegorical novel and part visionary history," as Holland Cotter described it in a *New York Times* exhibition review. Darger's work has been published posthumously in lavish volumes, and forty years after his death his stature as an artist continues to grow.

Or consider the prolific street photographer Vivian Maier,* whose story is told in the documentary film, *Finding Vivian Maier* directed by John Maloof and Charlie Siskel (2013). Maier worked as a nanny in Chicago. She took photos incessantly, developing them in her private bathroom. She did not tell a single soul about her obsession, her project, her life work, her art. Late in life she became destitute and placed her more than one hundred thousand negatives, slides, prints, and undeveloped rolls of color film in storage. After her death, a thrift auction house in Chicago auctioned them off. She was discovered by photographer John Maloof, who reassembled her oeuvre. She is considered one of the great

* Her work may be seen on the website John Maloof set up: *www.vivianmaier. com.*

street photographers of the twentieth century.

So, there are exceptions. Nevertheless, artists *do* require community. They *do* require the stimulating conversations, questions, challenges, and heartfelt support of peer artists.

In the world of creative writing, the critique group (also called workshop) has become the most common form of communal peer-group interaction. Let me begin, then, by critiquing the critique group. Not that I'm going to suggest it be dumped. But, too many writers go passively out to the critique group to passively accept the opinions of these good buddies. Keyword: *passive.*

Because my own quintessential teaching practice is for us to scrutinize virtuoso passages and pieces by world-class writers, I hear again and again (and again): "My critique group would pounce on this" or "My critique group would tear this to shreds."

What does this mean? Does it mean that the esteemed writers in the critique group think the Nobel Prize committee or the Man Booker Prize committee or the National Book Award committee has its head up its ass? Does it mean they don't read virtuoso writers or that they read them but fail to note their technical moves? Does it mean they are sticking to some "rule" they learned decades ago from some misguided teacher?

Often, I've come to believe, the critique group amounts to the blind leading the blind. And while I'm at it, I observe that critique groups spend way too much time discussing whether or not we "like" this or that work brought to the group from the world of published literature. You can dislike a work and still learn from its techniques.

Still, for artists who can maintain their independence and their boundaries, the good critique group is an invaluable resource. Our peers can see things we missed, can wake us up to weak spots before a piece makes its way out into the world. It can help us learn and grow as artists. My own workshop comprises poets, novelists, and painters. It has been running for nearly twenty-five years. I would not be without it. Without the stimulating conversations, questions, challenges, and heartfelt support of these fellow creators, I cannot even imagine where I would be at this point.

But the critique group or workshop is not a substitute for an artist's diligent, on-going self-education. We need to study. We need to educate ourselves. Most of the great creators become downright erudite in their areas of endeavor. We need to become downright erudite in our areas of endeavor. Consider one example: How many writers know what a chiasmus is? For those who know, it makes for a neat move. For those who don't, it may nevertheless arrive by chance (it is, after all, an ancient rhetorical form). Most likely though, such a writer will neither recognize nor ever use it. (A chiasmus repeats a phrase or statement in reverse order—ABBA—as in this biblical verse from Isaiah: "Woe to them who call evil good, and good evil; who put darkness for light, and light for darkness; who put bitter for sweet, and sweet for bitter!"*)

Multiply the example of the chiasmus (which can also take a visual form) by a hundred moves, strategies, rhetorical devices, paint-mixing techniques, you name it.

An artist's work might be divided into three stages:

* Isaiah 5:20 (*Holy Bible from the Ancient Eastern Text,* George M. Lamsa's translation from the Aramaic of the Peshitta).

the making stage, the critiquing and refining stage, and the purveying stage. The making stage is the gathering time, the ruminating, experimenting, questioning, fiddling, and beginning time, up to the point when the piece is getting there, ready to be seen. The refining stage is when the artist brings to the work his or her own critical acumen to begin reshaping, pruning, adding, subtracting. A late moment in this stage is when peer artists get a look and put in their two cents. The purveying stage is when you send it out the door, visit the gallery, enter a competition, mount a show, read at an open mic. Each stage has the potential to be nurtured within a community, whether the community is a gang of three or four or a single pal.

In the world of creative writing, we have "writing practice," in which writers gather at an appointed time and place and write for a timed half-hour and then read to each other what they have written and then go home and type. No critiquing here. Another fruitful strategy is to meet once a week with a fellow writer and just write.

Painters share studios and they share ideas. They get together to paint. Consider the Impressionist painters Auguste Renoir and Claude Monet. Renoir was the extrovert, Monet the introvert. According to Barbara Ehrlich White in *Impressionists Side by Side,* the two men painted in tandem for about ten years during their twenties and thirties (about 1865–1875), together developing the lighter palette and more visible brushstrokes later dubbed Impressionism. When, after a decade, their styles diverged, and Monet increasingly felt the need to paint in the company of himself alone, they nevertheless continued their friendship, their talk about art,

their high regard for one another's work. Each painted the other, purchased paintings from the other, and presented gifts of his own work to the other. In the mid-1880s, when they were living and working separately, it was Monet, the solitary one, who organized himself, Camille Pissarro, and Renoir, "to all dine together each month, so that we can get together to talk because it is stupid to isolate oneself."[*]

The late musician and visual artist Chuck Smart wrote, "The making of art for me is a matter of senses (what I see, hear, touch and taste), tools, comrades and a myriad of variables too numerous to mention. Comrades may be the most important of all. I trust the finished work that often results from the interaction with select fresh thinking comrades. I cannot emphasize enough the importance of this synergy."[†]

Creators need friendships and regular interactions with other creators. Non-creators don't really get it. And to work in isolation is to be both under-nurtured and under-stimulated. It's to risk re-inventing the wheel due to being under-informed about current practices, concerns, explorations. It's to miss the challenges and questions that fellow artists can bring to the process of creating a body of work. Art communities nurture artists and we artists need our art communities.

[*] Monet, 1884 letter to Camille Pissarro quoted in Barbara Ehrlich White, *Impressionists Side by Side* (New York: Alfred A. Knopf, 1996), 103.

[†] Chuck Smart's words and images may be found at *www.chucksmart.com*.

Questions to Contemplate as You Continue Your Practice

Do you have an adequate arts community, whether it consists of one or two buddies or more? Are your art buddies, comrades, or critique group members erudite enough to stimulate your own creative growth?

Do you make of yourself a valuable member of this community? Do you pay attention to the work of others and from time to time make yourself useful to their creative process?

Do you attend readings and openings? Do you write an occasional note of appreciation to an artist whose work is meaningful to you? Consider doing so.

XI.

Accounting for Works

I keep records of every piece made, and though effects
cannot be duplicated the records are stepping stones
to new experiments. Rarely am I pleased with the
results, but I keep on trying and that's important.
—Beatrice Wood, ceramics artist

A KEY STRATEGY of a remarkable number of virtuoso creators is to keep track of works completed. They do so in the manner of an accountant or an inventory clerk. The practice helps the artist to conceptualize each new piece as part of a body of work created over a lifetime. It helps the creative worker see where he or she has been. Without a systematic record, pieces are forgotten, mislaid, or inadvertently carted to the dump. The record of works marks the path traveled and that in turn informs a vision of the road ahead.

* Beatrice Wood quote in Crossing Thresholds Exhibition, January 26, 1999–February 28, 1999, University Art Museum, State University of New York at Albany *(www.albany.edu/museum/wwwmuseum/crossing/artist32.htm)*.

The British sculptor Andy Goldsworthy works outdoors with natural materials. He builds domes or cairns out of shoreline rocks balanced on one another, painstaking work begun at low tide and washed away by high tide. He constructs delicate, wind-rattled screens out of sticks of dried bracken descending from the branch of a tree. He scrapes iron oxide from red rocks and makes blood-colored pools by plopping the red pigment into the river. The river then makes the design, turning the iron oxide and shaping it and dispersing it.

Time is a key element in his work. Second by second, time passes and nature changes, taking his works and altering them or swallowing them. In a scene in *Rivers and Tides,* Thomas Riedelsheimer's documentary film about Goldsworthy,[*] the artist stands in his indoor studio before a wall of photos of his work. He explains that he has photographed his work, all of it, both good and bad, ever since art school. His works are accounted for, each and every one, across his entire lifetime of doing it.

In the 1960s when she was in her early twenties, Twyla Tharp—thinking "posterity"—began videotaping her dance workouts, experiments, and practice—her own and that of her dancers. She now possesses a library comprising four decades of improvisation. She says, "This is the first time a dancer has had this kind of library."[†]

The visual artist Faith Ringgold writes, "One of the first things I did when I decided to become an artist was to keep a record of all the work I had done in color slides, transparencies, and black-and-white photographs I also kept, arranged year by year, all my letters, reviews, articles, brochures, and catalogues in portfolios. Today my archive has grown from just a few portfolios on a shelf in my bookcase in the 1960s

[*] *Rivers and Tides* (2001), directed by Thomas Riedelsheimer.

[†] Norma Kamala interview with Twyla Tharp, uploaded September 28, 2010, Chic.TV Fashion, YouTube, *www.youtube.com/watch?v=atGJkkzVe54*

to an entire office of portfolios on shelves When I started in the 1960s, I didn't think about the market so much as I did amassing a body of work to be exhibited and reviewed, as well as making public appearances and acquiring a broad and appreciative audience for my art."[*]

I have found my own List of Works to be an essential tool. I can look at my list and tell you that as of this writing (May 2016) I have written 460 poems, 125 creative nonfictions or essays (the line distinguishing them can be fuzzy so I here lump them together), forty short stories, and six books (of which five are published, one is forthcoming, and one is residing—temporarily we must assume—under the bed). I also have a CV or résumé, which lists my *published* works, awards, education, and employment. The List of Works is a different kind of thing. It comprises all my works, successful or not, published or not. Every single poem, every single story or creative nonfiction or essay. Everything brought to the point of being typed up and brought to a first draft. Everything.

The List stands for the recognition I grant to myself and to all my struggles to become a writer. It recognizes my younger self by including all the work she ever got to the point of typing up. It reveals to me the range of material I've engaged with over the years and decades. Looking at the List helps me to see where I've been and that helps me to see where I'm going. It's happened more than once that I've looked at it and gone back to a piece I'd more or less forgotten. I've taken it up again, worked on it some more, sent it out, and seen it published.

The arrangement of the List makes it easy to comprehend

* Faith Ringgold, *We Flew Over the Bridge: The Memoirs of Faith Ringgold* (Boston: Little Brown and Co., 1995), 267.

at a glance. Each item takes up one and only one line. Each item has the word PUBLISHED or CIRCULATING beside it (or nothing beside it). Published works do *not* state *where* published. (The place for that is the résumé.) Circulating works do not state *where* circulating. Finally, the List of Works is ordered by years, beginning with the present and working backwards.

The List includes every single work. Do not leave one off because you think it's stupid or not good enough. For a writer, all works brought to the point of a typed first draft are included. The relevant date is the date when the first draft was completed, and revisions should not alter a piece's position on the list.

Creating the original version of the List of Works is labor intensive (you open another drawer and find another monotype, another poem, that play you wrote, back when). But as soon as you begin, the benefits begin accruing. Maintaining the List of Works by adding new work at the top, under the current year, is simple.

If you are a visual artist you might want to make one sheet per artwork, with an image of the work, along with such data as when made, size, materials, and current location.

Where are you as an artist right now? Where have you been? Where are you going? The List of Works (or chronologically ordered slides or other orderly chronological recordkeeping system that includes every single piece) is both a map of the past and a compass to guide the way forward.

Questions to Contemplate as You Continue Your Practice

⊛ *Have you inventoried your works?* If not, consider doing so.

⊛ *What person or institution will receive this body of work when you have to leave this world?*

⊛ *What did you learn about your body of work after making or updating your inventory?* Do you see directions and tendencies you were unaware of? Does a clearer notion of where you've been help to sharpen your vision of where to go?

⊛ *Write a vision statement laying out what you see as your next year of work.* Your next five years of work.

XII.

POET AS PEDDLER, PAINTER AS PUSHER: MARKETING

The endeavor of the artist is immensely personal,
yet, the result has public meaning.[*]
—Jacqueline Barnett, painter

THERE COMES A TIME, even for the artist who chooses to work mainly in seclusion or in secret—not so uncommon in the early years of effort—to begin engaging with the world, to begin putting the work out there, to begin presenting oneself as an artist, a poet, a novelist, whatever the case may be. It can be a good idea to delay this move. I often advise a client writing literary fiction or literary nonfiction to accumulate five or so completed, polished pieces before beginning to send out (if none are time-sensitive). The work, the creative worker, and the working process may require the shelter of privacy, at least for a time.

* Jacqueline Barnett, Statement for Harborview Hospital Application, November 16, 1991, in possession of Priscilla Long, Seattle.

Newly out in the open, you can feel exposed, embarrassed, even at times mortified. "What is an artist," wrote the sculptor Anne Truitt, "if not a hawker of homemade objects that have no practical use?" And to this she added, "every exhibition is poignant self-exposure."[*]

But ultimately, completed artworks—whether poem or painting or film—belong in the world. The work is connected to its maker but now also disconnected. Now it has a life of its own. But it is typically up to the author or artist to give it that life. To get it out of the house.

How to do this? The short answer: not timidly. I personally swear by the quota system. Approaching one agent, one literary journal, one gallery just does not work. Given good work, approaching forty agents, fifty galleries, or seventy-five literary journals does work. This has been demonstrated time and again. Besides, the quota system is more fun. When I set as my quota to send pieces or packets of poems to one hundred journals this year, I tend to sweat less over whether a particular journal will accept a particular piece. I focus on whether or not I am meeting my quota. And yes, the system works. One by one, over the years, the pieces do get published.

In the beginning it was not so easy. As long as I thought *marketing*, I hated the whole idea. But as soon as I began to conceptualize marketing as *connecting*, I improved. I'm as ambitious as anyone and just as fraught with the anxiety of ambition. But in putting out my work, I remind myself that it's not about me. It's about what is being presented: the poem, the creative nonfiction, the art.

[*] Anne Truitt, *Prospect: The Journal of an Artist* (New York: Scribner, 1996), 131.

I also remind myself that I am not the only person in the world. I try to make community. I try to see that this editor is also a writer and I try to discover what he or she has written. I try to see beyond my own "brilliant career," even if I don't always succeed. This morning a black-capped chickadee was flitting about in the vine maple right outside my kitchen window. I try to pay attention to such things, to the life going on around me. I try to be at least marginally aware of my neighbor, my fellow writer. I try not to be an egomaniac, even if I don't always succeed.

From time to time I try to lend a hand to another writer or visual artist. I try to articulate something meaningful about a book or exhibit I admire, and I try to do it *effectively*. If I'm going to praise a worthy book on Amazon.com, I stick the same blurb on LibraryThing, Barnes & Noble.com, Facebook, and on the website of Powell's City of Books—that fabulous independent bookstore in Portland, Oregon. Knowing that patron requests drive library acquisitions, I submit an acquisition suggestion to my local public library.

Fine, but how do you get your work into the world?

◉ The Mailing List

How big is your physical-address mailing list? How big is your email list? Cynthia Hartwig, marketing maven as well as literary writer, suggests—no, insists—that we build an email list of one thousand names.[*] Well then. Time to get busy. When a new work becomes available, do you inform your list? (Please use the "blind cc" [bcc] feature so as not to broadcast the email addresses of all your contacts.) Hartwig also suggests

* Hartwig's website may be found at Two Pens (*www.twopens.com*).

a once-a-month e-newsletter to your correspondents. An idea to consider.

◉ The Artist's or Author's or Writer's Website

Do you have a website? Get one. No, a Facebook page or the Amazon.com Author Page is not a substitute.

◉ Open Mics and Local Public Readings and Showings

If you are a writer, do you present at open mics? (Do this several times a year. Practice, stay within the time limit, stay to hear the other readers.) If you are a visual artist, do you, by yourself or with a buddy or two, show your work to the public, even if the public consists at first of your mother and your cat and even if the gallery wall also serves as a living room wall? Can you get together with fellow artists and put on a small group show, or a reading, with invited guests and maybe some wine and cheese? Do you attend the readings and openings of other artists?

◉ Sending Work Out

How many pieces do you send out to how many of the four-thousand-plus literary magazines, both in print and online, currently published in the United States? Many publish both literary and visual art. Can you set a goal for number of submissions, since sending out one piece and then waiting for a response is a certified waste of time? One year I sent out three hundred submissions and got eleven acceptances. And hey, I'm a *really good* writer. Now that I get more commissions

and requests, I try to send out one hundred submissions per year. Not one hundred different pieces of course, but perhaps five or ten pieces (or groups of three to five poems) sent out multiple times.

⊛ The Blog

Blogging is good, unless it's not. Do not blog because you think you ought. So many bloggers start out gung ho and then evaporate into the stratosphere. Yet I follow some stellar blogs and so do you, I'm sure of it. To write a good blog, a special and unique offering, takes real time, quite a bit of time. It is not something you can sustain unless it is intrinsic to your way of working and to the work you are doing.

One way to write a book is to blog it first, piece by piece, then refine it in the revision. Blogging can snag an audience for a book even before it *is* a book. And then the book gets the benefit of the blog's comments and reactions. An excellent book I'm currently reading, *Daily Rituals: How Artists Work* by Mason Currey, was done just this way.[*]

So why haven't I blogged the book you are here reading? I haven't blogged this book because I love to revise and re-revise and revise again. I've never heard of revising blog entries the next day or the next week. I begin each work session by reading from the top. On each pass, I tweak, cogitate, recast. Each time, the thing thickens and gets juicier. I like the slowness of not blogging, the chance to rethink and reduce and add and reconsider. I like the long period of focusing on the work itself and not on its audience. I like to work the sentences.

[*] Mason Currey, *Daily Rituals: How Artists Work* (New York: Alfred A. Knopf, 2013). Mason Currey's website may be found at *www.masoncurrey.com*.

There are pieces that you should under no circumstances blog. These are pieces that you are currently sending out to the magazines in the hope of getting them published. Publishing online is indeed publishing, in the view of many literary journals, and they will decline to consider reprinting or reposting.

The language pertaining to all this is fuzzy and ever-changing. My column, Science Frictions, which ran for ninety-two weeks on the website of the magazine *The American Scholar*, was called by the magazine a "blog," but I called it a column, in part because I put in perhaps twenty or thirty hours on each one. But certainly, that column, or blog, or whatever you want to call it, will one day form the core of a book.

In some cases blogging is the perfect way to share an interest or fascination or profession or avocation. In his blog, "Union Bay Watch" (unionbaywatch.blogspot.com), Larry Hubbell presents amazing photos and observations on birds and other animals in a nature preserve located within Seattle. In her blog, "Writing Ourselves Whole," (writingourselveswhole.org/voz-sutra/), Jen Cross blogs about writing as a way of healing from trauma. In "Bob and Jack's Writing Blog" (bobandjackswritingblog.com), authors and master teachers Robert J. Ray and Jack Remick blog about the craft of writing. These and other blogs are rich sources of reflection and knowledge and have become a cultural force in our world.

So blog if you want to, if it suits you, if it serves your purposes. But know that blogging is not obligatory.

◉ Other New Media

Do you tweet or interact with others on Facebook or on other new media? There's the up side (connection and interaction) and the down side (distraction). The writer Steve Almond nails the down side: "In practice, the Internet functions ... as a hive of distraction, a simulated world through which most of us flit from one context to the next, from Facebook post to Tumblr feed to YouTube clip, from ego moment to snarky rant to carnal wormhole."* Surfing the web, Almond elaborates, can be retreat from sustained attention and self-reflection. Can we use the new media enough to stay connected? Can we eschew the new media enough to stay focused?

◉ Old Media

Be eclectic. Have you considered the old-fashioned postcard, well designed and loaded with good blurbs? I carry a postcard that depicts and blurbs my how-to-write book (*The Writer's Portable Mentor: A Guide to Art, Craft, and the Writing Life*) and offer it instead of a business card. (The postcard purveys my web address and my website purveys my email address.) I've also mailed out about ten thousand of them so far. The "open rate" of electronic newsletters runs at about 15 percent. My postcard arrives open and it stays open. Its "open rate" runs at 100 percent.

◉ Grants and Residencies

Do you apply for grants and residencies? I routinely apply

* Steve Almond, "Once Upon a Time There Was a Person Who Said 'Once Upon a Time,'" *The New York Times Sunday Magazine*, January 13, 2013, p. MM44.

for two per year. Two applications take a moderate amount of time, whereas three or five would take an untoward amount of time. Applying serves to keep the résumé and artist statement up to date, and it never hurts to articulate what you are doing. Eventually, you get one. And then—another

⊛ Remain Flexible and Keep Learning

This chapter will go out of date in about three weeks; I guarantee it. But here's an idea that won't go out of date. In working to get your work into the world, create some sort of buddy system. In Seattle we have "the shipping group," started by my friend the writer Waverly Fitzgerald. The shipping group comprises five to seven writers, all sending work for consideration to literary magazines or agents or publishers. The group meets weekly at The Elliott Bay Book Company's café to report progress in sending out work and to discuss strategy and offer suggestions and mutual support.

In New York in the 1930s and 1940s, three painters—Mark Rothko, Barnett Newman, and Adolph Gottlieb—befriended the older, somewhat fatherly figure, Milton Avery.* The four friends spent summers together, painting all day and gathering in the evening to discuss the day's work. Back in New York during the cooler months, they got together for sketching classes, discussions, and literary readings. During the 1930s, Rothko helped to form the Group of Ten (consisting, actually, of nine men)—Jewish American painters who found themselves alienated from the two dominant current aesthetics (surrealism and regional American art).

* James E. B. Breslin, *Mark Rothko* (Chicago: The University of Chicago Press, 1993), 102, 162; April Kingsley, *The Turning Point: the Abstract Expressionists and the Transformation of American Art* (New York: Simon & Schuster, 1992), 61.

The artists gathered each month in one or another of their studios to discuss that painter's work and to debate art. They set out by twos to visit galleries. Over the years they succeeded in mounting eight group shows.

The buddy system works. Team campaigns make marketing tolerable, even enjoyable.

Do you have a forthcoming book or exhibition? Try inviting another author or another visual artist to have coffee. You want to pick their brains as to what got the word out most effectively in their case and what they might have done better. But here's a caution. Hesitate to *use*. Have you done your homework? Do you know this artist's work? Have you read their book?

There are blog tours and postcards, radio interviews, blurbs to be gotten The main point is that whatever is done must be done in a timely manner, and these days must be done mostly or even entirely by the creator. But it ought not to be done at the expense of the creative work itself.

Think of yourself—the writer, the painter, the video artist—as standing at the center of a ring of concentric circles. The innermost circle is the local ground, the ground on which the artist lives, the local arts scene—readings, open mics, galleries, and so on. Moving outward, you get less and less local until you reach national and international fame. Well. It happens.

Questions to Contemplate as You Continue Your Practice

🔘 **What are you doing to get your work into the world?** Do you function within the new media, as in Facebook, Twitter, etcetera? Do you over-function?

🔘 **Are you at least moderately active in your local arts community?** Do you connect with other artists, and how?

🔘 **How are you doing on walking that fine line between making work and marketing work?** If you have suddenly become more famous—perhaps you have a new book out or an upcoming show—are you still putting in time on the creative work itself?

XIII.

BECOMING A PUBLIC FIGURE

The celebrity factor, the work's reception, gives it a place.[*]

—Louise Bourgeois, sculptor

BECOMING A PUBLIC FIGURE is not exactly what we creators train for or even necessarily hope for. But for many creators it becomes a necessary part of putting work into the world. It may begin with a solo exhibition or a book launch or a debut concert. It may begin with an invitation to be interviewed on the radio or to teach a class or give a talk. Of course, this makes us happy—doesn't it? Our work is getting attention. We are gaining some recognition, some success. We may even start making some money for God's sake.

But here's the down side. Some of us are not natural public speakers. We are used to writing scenes or painting abstractions or weaving tapestries or composing music or

[*] Donald Kuspit, *An Interview with Louise Bourgeois* (New York: Vintage Books, 1988), 51.

choreographing dance. We are busy and we are shy. It may be necessary to prepare a talk, but that preparation may be costly in terms of time and anxiety and stress. And in the end, no matter how successful the talk turns out to be, it's not a new piece; it doesn't add to the body of work. What, exactly, has been accomplished?

Some might say, *Get over it!* Certainly most agents, who insist, "Writing is a business!" will decline to represent a writer whose public persona is discouraging or nonexistent. They are right, of course, because for them writing *is* a business. But the demands of art and the demands of business are two different things. Sometimes the stars align and the two meet and marry and live happily ever after. Other times, not. The physicist and thinker on creativity David Bohm writes, "A genuinely new and untried step may either fail altogether or else, even if it succeeds, lead to ideas that are not recognized until after one is dead."[*]

But suppose our ideas are recognized before we are dead? As the work becomes more visible, new demands intrude into the life of its creator, new obligations invade his or her days. In *Daily Rituals* Mason Currey reports that two creators—the author Francine Prose and the painter Chuck Close—each had a fine-honed routine before fame disorganized these routines.[†] Prose began writing when the children left for school and continued until they returned. Close used to work a steady six-hour day—three hours in the morning, break for lunch, three in the afternoon. Today each of these prolific artists continues to work but their routines are daily

[*] David Bohm, *On Creativity* (London and New York: Routledge, [1996] 2004), 21.

[†] Mason Currey, *Daily Rituals*, 63–64.

challenged by requests and duties that have emerged from their successes in getting their works into the world.

The sculptor Louise Nevelson reflected: "There are some people that maybe we are not recognizing, working quietly somewhere, who don't really want, subconsciously, the responsibility of a public life Then there are artists that may be very shy and really don't choose a public performance till they're ready. So it isn't always that they're not seen; it's that they don't want to be seen When one gets worldly success, so to speak, recognition, it is as hard to take success as it is failure. Both pull you out of the center unless the center matures, grows, and recognizes it. Being a public person requires quite a lot of things. After all, self-protection. You have to know how to handle it."[*]

Invitations proliferate; time evaporates. But if you start declining invitations, invitations start declining. You will rightly feel that you are hurting your chances for your work to gain a wider audience.

If you want to keep working though, you must set limits. It's as if an invitation were a chocolate gelato—good in small bites, bad as a stand-in for leafy greens. Determine the number of talks you will give per year, the amount of money you will charge for a talk, the number of pro-bono presentations you will give per year. If money starts coming in, even in moderate sums, consider employing a part-time assistant to help you plan or to just plain help.

I'm not famous. Still, on some days I get interrupted so incessantly you'd think I'd won the Nobel Prize in Literature.

[*] Louise Nevelson, *Taped Conversations with Diana MacKown* (New York: Simon & Schuster, 1976), 100, 137.

My best help with this problem of distraction and interruption is my intention to get four uninterrupted hours of work per day. The goal of time on the job—the job being the creative work itself, not teaching, answering email, sending work out, applying for grants, or other related tasks—is what keeps me on course. And make no mistake. I am looking with deep envy at the routine of three morning hours and three afternoon hours set up by Chuck Close (and also by the ultra-prolific Joyce Carol Oates).* For now, given my other responsibilities, I am usually getting four hours. My timer is my taskmaster.

As your work begins to gain more attention, it's useful to pay attention to how you want to present it, and to how you want to present yourself in public. As an artist who is visible, what is it that you want to convey? What values do you want others to take away? What do you want to say and what do you want to model about art and about making art? When you serve as a public figure, whether on the radio or in the classroom or in a live performance or at a gallery opening, you stand for art—for the particular form of art you make, as well as for all art. That's a responsibility.

It may be helpful to take a class in acting or in the Alexander Technique, a body alignment practice developed originally for performers. I've done both and both helped me overcome my original stage fright. There are improvisation classes, classes in performing, classes in public speaking.

Look for model creators, past and present, who are visible in the culture, artists you admire. What can you learn from them by way of comporting yourself as a public figure? One I stand in awe of is Twyla Tharp as interviewed

* Currey, *Daily Rituals*, pp. 62–63.

(on YouTube) by Norma Kamali.* I'm looking at Tharp's posture, her thoughtful and erudite responses, her dress, her lack of stuttering and stammering, her sincere and extremely professional presentation and the quintessential brilliance of the content she presents.

It helps to gather three or four such examples to study. How do they dress? How do they comport themselves? What does their body language convey? What do they say and how do they say it? We also happen upon negative examples and learn from these as well.

And then we practice. We get a buddy or two to give a trial presentation to, to get their feedback. We videotape ourselves. We time ourselves and religiously decline to exceed our allotted time. We learn to relate to an audience, to respect its members, to feel comfortable in their presence and with their own dreams and questions.

* Kamali interview of Tharp, *www.youtube.com/watch?v=atGJkkzVe54*

Questions to Contemplate as You Continue Your Practice

⊛ **Can you look at one or another public figure you see in the arts and choose one or two models**—people you admire for their values and presentation?

⊛ **If you had to speak to an audience,** whether of fourteen or four thousand, what are the three most important things you would want them to know? Can you get someone to give you feedback on your teaching or talk or radio or TV interview?

⊛ **Practice presenting your work or giving a talk using a video or audio recorder.** What do you see as your strengths? What could use work?

DEVELOPING HIGH
SELF-REGARD

*The men liked to put me down as the best woman
painter. I think I'm one of the best painters.*
—Georgia O'Keeffe

PART OF LEARNING to do creative work is learning
to be kind, patient, generous, forgiving, and lenient, not
toward others so much as toward yourself. It's vital to refrain
from habitually calling yourself (to yourself) *dumb shit,
mental retard, asshole*, and the like. Stop doing that. The muses
dislike it.

If you are one who feels chronically inadequate or inferior
or even worthless at times; if you hope overmuch to please a
teacher or mentor or lover or stranger you admire more than
you admire yourself; if you can't bring yourself to believe in
yourself; if you find yourself vaguely discouraged all the time,
it becomes difficult or impossible to bring to your creative

* Georgia O'Keeffe quoted in Whitney Chadwick, *Women, Art, and Society* (New York: Thames and Hudson, Inc., 1990), 284.

work the dogged energy and daily care that creative work requires.

Such feelings are not our own fault. Most result from personal history over which we had no control. Maybe we were yelled at altogether too often as children, or were in other ways emotionally battered or sexually abused. Maybe teachers dissed our abilities or insulted our dignity. Maybe we were traumatized on the battlefield or in a personal assault and this worked its corrosive psychic corruption in shattering our self-esteem. Maybe we find ourselves in an abusive relationship or maybe we are just depressed.

If any of this applies to you, you owe it to yourself as a creator and an artist to get help, to avail yourself of the professional assistance of one of the many counselors and healers at work in your community. Do this not only for your own sake but for the sake of your art. Artistic expression, writes Shaun McNiff, "has a unique and timeless ability to touch every person in times of personal crisis and collective distress."*

Indeed, making art, learning to make art, is one of the great healers.

We can learn in specific and concrete ways how to honor our lives and our creative work. Our teachers are those who have studied self-esteem, who have observed the actions and strategies of persons who live their lives with high self-esteem, regardless of circumstances. To begin with, they treat themselves with respect. They honor themselves and recognize their own efforts.

"Treating ourselves well," writes Marsha Sinetar in *Do What You Love, the Money Will Follow,* "is a step that can

*McNiff, *Art Heals*, 4.

rapidly build self-esteem. Research studies show that people who have high self-esteem regularly reward themselves in tangible and intangible ways. Their tangible rewards consist of concrete items they enjoy—e.g., purchases, activities, 'time off' for vacations. Their intangible rewards may be in the form of self-statements that say they have done the best they could, or that they are happy with themselves. More importantly, their rewards carry with them messages, both symbolic and actual, that say they are worthwhile, that they deserve good things, and that they have succeeded in their own eyes. By documenting and celebrating their successes, they ensure that these successes will reoccur."[*][†]

I believe, along with Nathaniel Branden (*The Six Pillars of Self-Esteem*), that self-esteem is the health of the mind. Branden writes, "To face life with low self-esteem is to be at a severe disadvantage."[‡] I say, to face making art with low self-esteem is to be at a severe disadvantage. Branden says, "Your life is important. Honor it. Fight for your highest possibilities." I say, your art, your creative work, is important. Honor it. Fight for your highest possibilities.

As Branden elaborates, achieving high self-regard is not a matter of standing in front of a mirror and telling your reflection how talented or beautiful you are. Neither is it a matter of saying affirmations—"I'm charming and so brilliant." As a technique for improving self-esteem, this is silly, even if what you tell yourself about yourself is not silly.

[*] Marsha Sinetar, *Do What You Love, the Money Will Follow* (New York: Dell Publishing, Random House, 1987), 60.

[†] McNiff, *Art Heals*, 4.

[‡] Nathaniel Branden, *The Six Pillars of Self-Esteem* (New York: Bantam, 1994), xi, xiii.

Improving self-esteem is a matter of taking regular steps, no matter how small, to set goals to achieve what you intend to achieve, to live the life you aspire to live, to live according to your values and according to your dreams. It's a matter of working in regular small steps to create the art you dream of leaving in the world once you are gone.

I look back a long way to when I was a young woman dreaming of being a writer. In my twenties I wrote poems; I wrote in my journal. I began researching the labor organizer Mother Jones and the history of coal mining. I was a political activist working to end the war in Vietnam, to "bring the boys home." I worked in the women's movement (1969–1972) and later in the movement for peace and justice in the Middle East. I was a reader, I had good friends, and I entered the printing trade. I was good at what I did, but ever-anxious to please. I did not have confidence in my writing. Most of us don't at that stage. I could not put my writing first.

Two "self-help" books were transformative, and perhaps they dropped into my life at a time when I was receptive to their wisdom.* One was *The New Diary* by Tristine Rainer. I spent many hours one dark winter, a time of longing and depression, working on the exercises in that mensch of a book. The other was *Becoming a Writer* by Dorothea Brande. Brande requires you to write for fifteen minutes every day. I read her book in 1980 and that's about when, notwithstanding previous writings and early publications, I became a real writer. Or so it seems to me. Every day since, I've put in my fifteen minutes. Usually more, virtually never less.

* Tristine Rainer, *The New Diary: How to Use a Journal for Self Guidance and Expanded Creativity* (Los Angeles: J. P. Tarcher, 1978); Dorothea Brande, *Becoming a Writer* (New York, Harcourt, Brace, 1934).

Self-esteem is not a fixed quantity. Rather it's a feeling, fluid and changing. But I can say that over the years, with a little help from my friends, with a little help from a couple of good therapists, with a little help from a couple of good self-help books, I've evolved into a writer who has consistently high self-esteem. It helps me to be productive, to get my work out, to keep working on my work. It gives me resilience in the work.

You have what it takes to make art, if you make the choice to *take* what it takes. None of us knows whether our work will end up being great or not great, remembered or forgotten. But we are in control of that steady work process that is engendered by believing in our selves and in our lives and by respecting the work we have undertaken.

Sustaining creative work requires respecting yourself, honoring your life, and the humility and faith to keep going despite the ambiguity of creative work and the lack of guarantees regarding either artistic outcome or recognition. Honor yourself and your work as if the world depended on it.

The world does depend on it.

Questions to Contemplate as You Continue Your Practice

🔘 **Do you treat others with respect and kindness?** Do you honor other creators in your community and pay attention to their work? Can you improve in this endeavor by 5 percent?

🔘 **Do you have very high self-esteem?** If this is an area that needs work, what work can you do? If you feel you need help, the time to research and access that help is now.

Epilogue

A LIFE IN ART requires resilience, imagination, and a willingness to grow. It requires the ability to withstand unpopularity, or more likely, years of being ignored. It requires the ability (arguably more challenging) to withstand popularity or even celebrity. It asks us to acquire some humility as we follow in the footsteps of a long line of predecessor creators. It also asks us to be egotistical and stubborn, to make our own way.

A life in art does not preclude commercial success and it does not excuse us from working to get our art into the world. But—and this is my deepest belief—it does ask us to separate the making of art from the selling of art. However much the selling (publishing, showing, whatever) requires our attention, we always return to the empty stage, the blank canvas, the blank page. And that is—I'm here to say—the great joy of a life in art. Everything else falls away.

If a life in art is a chosen life, a self-directed life, it's also a life lived in community, including the community of readers and viewers and hearers and that of other artists. And yes, there will be rejections, financial worries, periods of floundering and searching. There will be times when heavy responsibilities do not allow for more than a half-hour of work a day. There will be looks askance: the neighbor who had developed the mistaken notion that I was a college professor. No, I told her. I'm a poet.

There will be all that and more. But a life in art is the best kind of life. You know how good it is. I, for one, cannot imagine a better one.

Acknowledgments

First thanks go to three dear friends whose lives have stood as emblems of the creative life: the painters Flynn Donovan, Gordon Wood, and Jacqueline Barnett. The idea for *Minding the Muse* presented itself during a convivial dinner with my old friend the writer Waverly Fitzgerald. Her first read and the insights and suggestions of the other first readers improved it immensely. I thank my sister Pamela O. Long and brother-in-law Bob Korn; my niece Joanna Long; and the writers Elana Zaiman, Bethany Reid, Jack Remick, Alice Lowe, and Jay Schlechter. Ms. James Kessler scoured the text with her eagle eye, to its everlasting benefit. I wish I could thank the late Chuck Smart in person for his painting reproduced on the cover and for the example of his life in art.

My third-Sunday workshop, sometimes taking the form of the group of performing poets The Seattle Five Plus One, has been indispensible to my life and work. Erudition combined with conviviality combined with commitment over twenty-five years. Thanks, with love to M. Anne Sweet, Geri Gale, Jack Remick, Gordon Wood, and Don Harmon.

I'm lucky to have a fabulous team that meets once a month at the café at Seattle's Elliott Bay Book Company to cogitate on getting work into the world and to report on progress: Andrea Lewis, Susan Knox, and again, Waverly Fitzgerald. I further thank The Elliott Bay Book Company

itself—this large, thriving, independent bookstore stands at the heart of Seattle's cultural life.

I've been nurtured and sustained at Hedgebrook, the retreat for women writers. The chefs at Hedgebrook should be cooking for the gods. Since they cook for us writers instead, I conclude that the gods have no need of food.

Finally, the enthusiasm and professionalism of Catherine Treadgold and Jennifer McCord at Coffeetown Press in bringing this work to light is truly gratifying. Thank you.

INDEX

About the Author

Photo by Tony Ober

PRISCILLA LONG is a Seattle-based author and teacher of writing. Her work includes poetry, creative nonfictions, fictions, history, and science. Her most recent books are *Fire and Stone: Where Do We Come From? What Are We? Where Are We Going?* and *Minding the Muse: A Handbook for Painters, Composers, Writers, and Other Creators.* Her book of poems is *Crossing Over: Poems* (University of New Mexico Press, 2015). She is also author of *The Writer's Portable Mentor: A Guide to Art, Craft, and the Writing Life* and the scholarly history book *Where the Sun Never Shines: A History of America's Bloody Coal Industry.* Her work appears widely in literary journals and her awards include a National Magazine Award. She has been a fellow at Hedgebrook, the Millay Colony for the Arts, and the Jack Straw Productions Writer Fellows Program. She serves as Founding and Consulting Editor for *www.historylink.org,* the online encyclopedia of Washington state history.

For more information please visit *PriscillaLong.com* and *PriscillaLong.org.*